Contents

foreword

The exhibition *Australian gold and silver, 1851-1900* is a sumptuous collection of rare and valuable pieces from the museum's own holdings augmented by some extraordinarily generous loans from many public and private collections in Australia and England. Objects that are rarely exhibited and pieces never before on public display such as the Dunedin Centrepiece made about 1864 by Julius Schomburgk and Christian Qwist's 1871 Sydney Cup are featured, making this perhaps the most important exhibition of Australian 19th century jewellery and presentation pieces mounted in this country. It has been assembled to celebrate the occasion of the reopening of the Sydney Mint Museum on Macquarie Street, Sydney, in March 1995.

The Sydney Mint proper opened 140 years earlier in 1855 to produce gold sovereigns and half-sovereigns and to provide the material for silversmiths following lucrative discoveries in the new goldfields after the first strike in 1851.

The confidence resulting from the gold boom infected much of society. European silversmiths found in Australia both a source of gold and silver and patronage to support their work. In the period 1851-1900 they produced exquisite and often highly original objects such as jewellery decorated with motifs of indigenous flora and fauna, silver-mounted emu eggs and elaborate testimonials and trophies. It is these objects of adornment and celebration that form the core of this exhibition and the focus of this book. Wherever possible the pieces selected are the finest examples of gold and silver objects made in colonial Australia.

Gold fever attracted opportunists from around the world and in the process caused a substantial restructuring of Australian society. Many colonists abandoned their trades and professions to dig for gold and many others came to Australia to practice their skills in the new climate of opulence. The colony of New South Wales threw off the mantle of a penal colony and, together with Victoria, South Australia and later Western Australia, flourished in the new wealth the gold rushes brought. Sydney in particular developed as a hub of metallurgy and scientific research, and became for a time an international financial centre.

This book delves into aspects of gold mining history in Australia, and looks at the symbolic and social significance we attach to metals and mints, the creations of the silversmiths and jewellers whose material the Mint helped make available. It also provides an opportunity to focus on the history of the museum's collection of decorative metalwork, which is such a strong feature of the exhibition. The chapters are written by the museum curators who developed the Sydney Mint Museum exhibitions, in cooperation with colleagues from all departments of the Museum of Applied Arts and Sciences.

Terence Measham
Director

AUSTRALIAN

gold & *silver*

1851-1900

edited by Eva Czernis-Ryl

POWERHOUSE PUBLISHING
part of the Museum of Applied Arts and Sciences

Design: Mad House Design
Editing: Bernadette Foley
Photography: Andrew Frolows*
Desktop publishing: Renée Roos* and Catherine Dunn*
Production coordination: Julie Donaldson*
Printing: Griffin Press, Adelaide
*Powerhouse Museum staff

Published in conjunction with the exhibition *Australian gold and silver, 1851-1900* curated by Eva Czernis-Ryl at the Sydney Mint Museum, March 1995-March 1996.

The museum gratefully acknowledges the contribution from J B Hawkins Antiques towards the production of this publication.

CIP
Australian gold and silver 1851-1900.
Includes index.
ISBN 1 86317 052 9.
1. Goldwork — Australia — History — 19th century. 2. Silverwork — Australia — History — 19th century. I. Czernis-Ryl, Eva.
739.2099409034

The Museum of Applied Arts and Sciences incorporates the Powerhouse Museum, the Sydney Mint Museum and the Sydney Observatory.

Every effort has been made to provide correct acknowledgment for the photographs reproduced in this publication. All inquiries should be made to Powerhouse Publishing.

First published 1995
by Powerhouse Publishing
part of the Museum of Applied Arts and Sciences
PO Box K346 Haymarket NSW 2000 Australia.

acknowledgments

The museum gratefully acknowledges the following people who generously shared their knowledge and offered valuable comments toward this publication: Kurt Albrecht, Brian Eggleton, Dr Dorothy Erickson, Kevin Fahy, John Hawkins, Jolyon Warwick James, Christopher Mentz, Anne Schofield, Ann Stephen and Kimberly Webber. And the many museum staff who have contributed to its production.

Any writing on Australian colonial silver and jewellery must be indebted to information published in John Hawkins' *Nineteenth century Australian silver* and *Australian jewellery, 19th and early 20th century* by Anne Schofield and Kevin Fahy, and *Australian jewellers, gold and silversmiths, makers and marks* by Kenneth Cavill, Graham Cocks and Jack Grace.

The exhibition, which this publication accompanies, would have not been possible without the generosity of the many institutions and individuals who lent their objects: Adelaide Botanic Gardens & State Herbarium; Agricultural Bureau of South Australia; Kurt Albrecht; Art Gallery of South Australia, Adelaide; Mrs Olwen M H Atkinson; Broken Hill Historical Society Inc; Buda Historic House & Garden Inc; Christ Church, North Adelaide; Graham Cox; Jack Grace; Mrs V Gregg; John Hawkins; John Houstone; H P M Industry; Mrs H R Jenkins; Trevor Kennedy; Mitchell Library, State Library of New South Wales, Sydney; Misses G & G Lewis; Diana Morgan; National Gallery of Australia, Canberra; National Gallery of Victoria, Melbourne; Queensland Art Gallery, Brisbane; Rare Art (London) Ltd; Michel

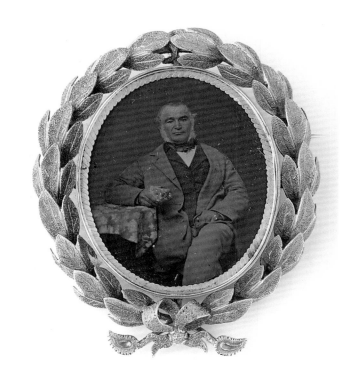

Locket brooch made of gold, hand–coloured ambrotype, glass, fabric and paper. A tribute to a man and his gold. Made in Australia about 1860. Maker unknown. Private collection

Reymond; The Trustees of the Roman Catholic Church for the Archdiocese of Sydney; Anne Schofield; Salisbury Catholic Parish; Scots Church, Sydney; Smith family, Perth; decendents of Sir Alfred Stephen; St Patrick's Catholic Cathedral, Melbourne; Tamworth City Gallery; Miss Traill's House, Bathurst – National Trust of Australia (New South Wales); Mary Titchener; University of Adelaide; Dr Leonard and Phyllis Warnock; and anonymous private collectors.

In addition, acknowledgment of the vision for the transformation of the Sydney Mint Museum and its new exhibitions rests with director, Terence Measham and the then manager, Collection Development and Research, Dr David Dolan.

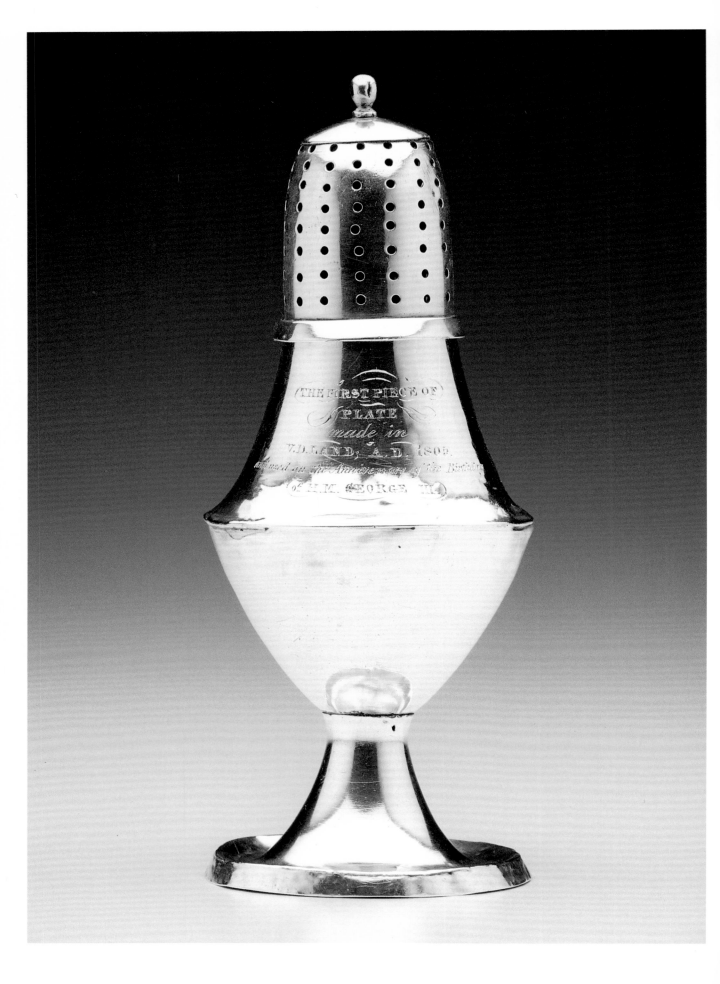

australian gold and silver, 1851-1900

EVA CZERNIS-RYL

AUSTRALIAN GOLD AND SILVER BEFORE 1851

Long before significant gold deposits were discovered in 1851, making Australia an attractive destination for skilled silversmiths[1] from Europe, this country was the involuntary home to a number of convict craftspeople transported to the penal colony for offences such as banknote forgery or illegal hallmarking of silver. In fact, a few jewellers and silversmiths arrived with the First Fleet in 1788. William Hogg, a silversmith aboard the *Scarborough*, is perhaps the best known.

As only the elite of the small European population in the colony could afford luxury wares there was limited demand for the work of the silversmiths. Once free, they embarked on other careers. In the first two decades of the 19th century, however, a few entrepreneurs succeeded in setting up businesses in Sydney and Tasmania which concentrated on retailing imported jewellery, watches and repairs.

Gradually, the market for locally made objects increased and in the first half of the 19th century it was not uncommon to read advertisements in the *Sydney Gazette* offering the services of working jewellers and silversmiths. Silver and gold were in short supply and the advertisements often announced the silversmiths' intentions to acquire 'gold ducats at twice their value' and silver coins at 'the best prices'. Despite Governor Macquarie's proclamation of 1813 which prohibited the use of currency in the trade, melted coins remained an important material for locally made products.

The first recorded items of colonial Australian jewellery are necklaces and earrings made in about 1803 for Governor King's wife, Anna Josepha Coombe, and their daughter, Elizabeth, by Ferdinand Meurant.[2] Meurant, a jeweller trained in Dublin, and John Austin, a seal and copperplate engraver also from Dublin, were convicted of forging Bank of Ireland notes and arrived in Sydney in 1800. These craftsmen may have been responsible for the making and bright-cut engraving of the gold-mounted turbo shell snuffbox presented in 1808 to the Reverend Patrick Davidson, an Aberdeenshire ecclesiastic, on the occasion of his son's last visit to Australia (pl. 51).

The earliest surviving silver object fully made in Australia is attributed to the Tasmanian silversmith James Grove. The pepper caster, which is designed in the neoclassical style, was presented in 1805 to David Collins, first Lieutenant Governor of Tasmania (pl. 1).

Both Meurant and Grove were still prisoners when they made the necklaces and caster. Alongside other convicted tradespeople in Australia, however, most silversmiths enjoyed better conditions than untrained convicts. From at least 1815, it was a common practice for the newly arrived jewellers, engravers and

Plate 1, page 6 **Silver pepper caster attributed to James Grove. This piece was made in Hobart about 1805 and was exhibited in the 1855 Paris Exhibition. It is inscribed: 'The First Piece of Plate made in V. D. Land, A. D. 1805, and used on the Anniversary of the Birthday of H. M. George III.' Unmarked. H. 14cm.**

Private collection

Plate 2, page 7 **Detail of bracelet (*see plate 7, page 15*).** Lent by the Smith family, Perth, Western Australia.

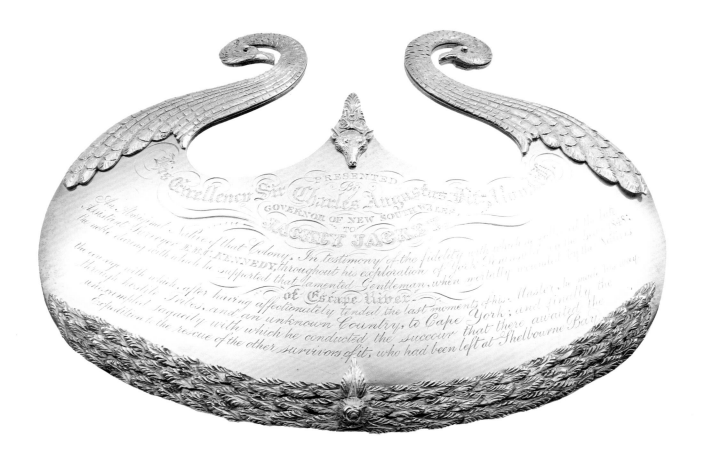

Plate 3 **Breastplate or gorget in silver made by the firm Brush & MacDonnell in Sydney about 1851. It was presented by Governor FitzRoy to Jackey Jackey, an Aboriginal man who accompanied the explorer Edward Kennedy on the ill-fated expedition to the Cape York Peninsula in 1848. Although there were many brass, bronze and copper breastplates presented to Aboriginal people in colonial Australia, this is the only one known to have been crafted in silver. Unmarked. W: 15 cm.**

Lent by the Mitchell Library, State Library of New South Wales.

silversmiths to be assigned to the existing silversmithing workshops. In return for their services, their sentences were often considerably reduced and they soon were able to establish their own businesses. Some, like Grove, who became a friend of Lieutenant Governor Collins,[3] counted themselves among friends of distinguished colonists and, consequently, must have enjoyed some patronage.

In general, though, it appears that the jewellery and silversmithing trades were held in low regard in the colony in the early 19th century. In his *Reminiscences of thirty years' residence in New South Wales and Victoria*, Judge R Therry described Sydney's George Street as:

> brilliant with jewellers' shops ... this display of splendour was, after all, a very natural result of the convict element in the town. The receivers of stolen plate and articles of *bijouterie* in England had chosen Sydney as a safe depot for [their] disposal ... The

Sydney confederates returned the compliment to their London allies by melting down stolen silver, and sending it to England.[4]

When making this comment Judge Therry, a new Commissioner of the Court of Requests, would have been familiar with the results of the 1828 Census of New South Wales which recorded Sydney's silversmithing and jewellery trade as consisting of about thirty craftspeople who served a population of approximately 11,000. Only five of those listed were free settlers who had begun emigrating to Australia in the early 1820s.[5]

Probably the first free silver retailer to work in Australia was a Scotsman, James Robertson, who came to Sydney with Governor Brisbane in 1822 as a keeper of clocks and instruments. During the next eight years he also ran a retailing business, mostly importing English and Cantonese silverware. Robertson's local orders, including the colony's first ecclesiastical commission, a pair of regency style chalices and patens presented to the Scots Church in Sydney in 1826, are attributed to Alexander Dick, the best known of early Australian silversmiths.[6]

Alexander Dick, also a free settler from Scotland, arrived in Sydney in 1824. Initially probably employed by Robertson, Dick soon established his own business which prospered until 1829 when he was transported to Norfolk Island for receiving stolen spoons. These he had refashioned to fulfil urgent orders. Dick returned to Sydney in 1833 and for the next ten years continued to gain major commissions including Australia's earliest gold racing cup of 1834 which is now lost. Although a substantial group of Dick's flatware survives today, only a few pieces of holloware, jewellery, several snuffboxes (pl. 49) and pap boats, as well as other small presentation pieces bearing his maker's mark have been located.

Dick's counterpart in Tasmania was another settler of Scottish origin, David Barclay, who worked in Hobart from 1830 to 1878. He employed the assigned convict Joseph Forrester who appears to have been responsible for much of the output of Barclay's workshop up to the early 1840s.[7] Among the most interesting works attributed to Forrester is a series of richly *repoussé* salvers made for presentation to distinguished individuals in Hobart, Sydney and Melbourne.[8] The distribution of these salvers from Hobart to New South Wales and Victoria indicates the scarcity of silversmiths in the colonies in the 1840s who were able to execute substantial commissions. A notable exception was an Adelaide silversmith, Charles Edward Firnhaber, who by 1851 had made a few splendid presentation cups in the rococo revival style and an outstanding gothic revival communion set.

Despite the impression of a relatively busy scene of Australian silversmithing before the gold-rush era, little was made locally during this period. Early silversmiths concentrated on retailing imported jewellery, watches and tableware and on repairs, ordering most of the larger commissions from England. Whatever they made was based predominantly on English models. The surviving objects confirm the popularity of the English regency style which, in the 1830s, began to coexist with the generous curving shapes and scrolling decoration of

rococo revival. Firnhaber's communion set was an exception.

THE IMPACT OF GOLD: MAKERS AND PATRONS

Gold discoveries in the second half of the 19th century in Australia resulted in a phenomenal growth in population and offered the community new skills and ideas. Among the thousands of immigrants were a number of accomplished jewellers and silversmiths from the German states, Denmark, France, Austria,

Plate 4 **This brooch is inscribed on the reverse: 'Presented Melbourne Dec 28 1855 to Madame Lola Montez by her Friends in Victoria as a proof of their esteem.' It is made of gold and garnets by an unknown silversmith who probably produced it in Ballarat or Melbourne in 1855. Unmarked. W: 8 cm.** Private collection

Hungary, the divided Italy and the British Isles. They settled mainly in Sydney, Melbourne and its satellite

Plate 5 **Improvident diggers in Melbourne,
about 1852 by S T Gill (1818–1880),
watercolour, 25.0 x 19.1 cm.**

Reproduced courtesy of the City of Ballarat Fine Art Gallery.

Gift of Tony Hamilton and Miss S E Hamilton, 1907.

sophisticated needs. The new, rapidly growing middle class could now support a range of learned and friendly societies, and excelled in fostering sporting competitions. Australia's first universities were established, and the developing towns and cities acquired new railways, town halls, hospitals, cathedrals, churches and synagogues.

The new societies and institutions commissioned presentation pieces ranging from jewellery and silver-mounted emu eggs to sporting trophies and impressive testimonials, which have now become synonymous with later 19th century Australian gold and silver. Derived from the ancient custom of presenting silver and gold objects as tributes to individuals on special occasions, these extravagant pieces were highly regarded during this period. They were usually presented, with Victorian pomp and ceremony culminating in enthusiastic press reports, to city aldermen and other officials, clergy, winners of sporting competitions, departing or retiring public servants, departing governors' wives and daughters, popular actors and visiting entertainers, members of the Royal family and even the Pope. Occasionally, silver breastplates were presented to selected Aboriginal people in recognition of their assistance to the community (pl. 3). Throughout almost all sections of colonial society, there was a continuing demand for locally made gold jewellery acquired mostly as gifts for family and friends both at home and abroad.

To the makers, patrons and recipients in post-1851 Australia, presentation pieces and jewellery held a special meaning as they not only marked personal

towns, and Adelaide and had a profound impact on the production and stylistic developments of Australian jewellery and silversmithing throughout the later 19th century and beyond.

These crafts flourished amidst the unprecedented prosperity that gold brought to Australia. The vast increase in capital stimulated developments in agriculture and mining, commerce, the arts and industry. Society became more complex with more

achievements, but reflected colonial pride and gold-boom confidence. As such they were much admired symbols of colonial progress. Unfortunately, only a small amount of 19th century Australian gold and silver ware survives. Numerous pieces have been lost or destroyed and are known to us only through contemporary records.

Plate 6 **This brooch depicts a bouquet of Australian flora including native pear, fern leaves and banksia. Made from gold and gold-flecked milky quartz it was produced by Hogarth, Erichsen & Co in Sydney about 1858. Unmarked. H: 5.3 cm.**

Powerhouse Museum A 6486

THE GOLDEN DECADES: 1850s AND 1860s

Despite the economic depression of the early 1840s, by the beginning of the following decade Australia was a reasonably prosperous country. In 1850 two major London-based jewellery and silver importing firms began operations in Sydney. Flavelle Bros and Brush and McDonnell were later joined by firms such as Hardy Bros in Sydney and Kilpatrick & Co in Melbourne. When the discovery of gold created a boom in luxury trade, they sent their orders, often

together with 'pure Australian gold', to English manufacturers delighted by the burgeoning market.

In the early 1850s these large firms supplied a number of substantial presentation pieces such as the massive silver Cooper Vase made by a leading London manufacturer Hunt & Roskell, now in the collection of the Powerhouse Museum. Generally, it was not until about 1856 that commissions for larger presentation pieces in gold and silver were entrusted to local makers. By that time, accomplished immigrant silversmiths could more than satisfactorily meet the growing demand.

It was in the area of Australian jewellery, however, that the impact of gold discovery and the resultant gold rushes was immediately felt. By the mid 1850s, some of the gold bullion and nuggets found in New South Wales and Victoria were made into a distinctive type of jewellery, known as goldfields or digger jewellery. These intricately designed brooches, pins and rings were composed with groupings of naturalistically rendered miniature mining equipment, often with a gold nugget prominently featured in the centre of the design. Many of the surviving brooches illustrate complex, almost heraldic compositions which include small figures of miners turning windlasses, and surrounded by sluice boxes, pans, picks and shovels, bags of gold and even pistols, all set within foliate, wreath-like frameworks (pl. 22 and 24).

It appears that the early goldfields jewellery was made by adventurous jewellers who, after unsuccessful attempts as miners on the goldfields, set up specialist shops in gold townships such as Bendigo (from 1853 to 1891 known as Sandhurst) and Ballarat. These sentimental mementos of miners' hardships and, more importantly their successes, were treasured as souvenirs of Australian goldfields which lucky diggers took home as presents for family and friends (pl. 5). Although relatively expensive, this jewellery was purchased by visitors to the goldfields as 'proofs of colonial advancement'.[9] Some of the larger brooches were devised in the emerging spirit of Australian identity. A spectacular brooch designed to represent a digger's Australian coat-of-arms was presented in 1855 to Lola Montez, a visiting European courtesan and dancer who captured the hearts of 'her friends in Victoria' (pl. 4). By this time a variety of goldfields brooches and rings could be bought or commissioned from large city establishments.

In Sydney, by the mid 1850s, a different type of gold jewellery, inspired by Australian flora and fauna, and sometimes including figures of Aboriginal people, had also appeared. Often original in design and exquisitely executed, these massive, highly naturalistic brooches and bracelets were probably devised in the studio of the Danish-born sculptor Julius Hogarth and his partner Conrad Erichsen of the firm Hogarth, Erichsen and Co, jewellers and medallists working in Sydney from 1854 to 1861 (pl. 6 and 7).

Australia's earliest known brooch decorated with an Aboriginal figure with a spear and an emu and kangaroo was made by Erichsen and exhibited at the 1854 Sydney colonial exhibition where it was awarded a bronze medal.[10] From then on, the firm produced a variety of pieces ranging from smaller brooches with

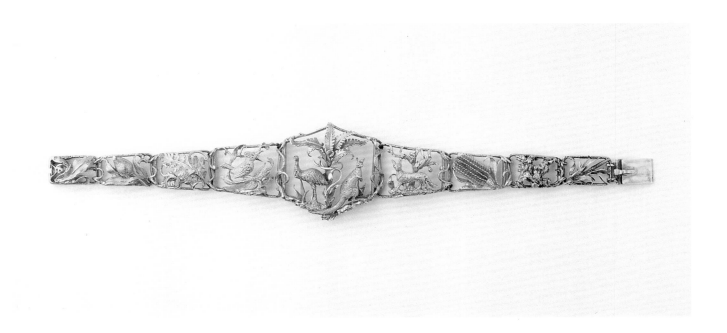

Plate 7 **Hogarth, Erichsen & Co, Sydney, are attributed with making this gold bracelet in about 1858. The design includes an emu and kangaroo, a kookaburra, dingo and examples of native flora. Unmarked. H: 5.5 cm.**

Lent by the Smith family, Perth, Western Australia.

an emu and a kangaroo beneath a palm or grass-tree (similar to their designs for silver threepenny tokens issued from 1858 to 1860), to elaborate openwork bracelets featuring impressive groupings of native animals and plants as well as local gemstones, Moreton Bay (Queensland) pearls and South Australian malachite.

While jewellers emulated Hogarth and Erichsen's work with Australian motifs they also produced jewellery in fashionable international styles such as naturalism (focusing on European flowers, 'rustic' tree branches and foliage) and historical revivals. In fact, it seems that the majority of Australian jewellers concentrated on making European-style jewellery using local gold and gemstones. Among the most striking examples of early jewellery designed in the international styles are brooches, bracelets and pendants made by, and attributed to, Alfred Lorking and Hardy Bros of Sydney, Charles Firnhaber of Adelaide (pl. 8), Ernest Leviny of Castlemaine, Victoria, and Melbourne's Hackett Bros (also the makers of the magnificent William Smith O'Brien gold cup of 1854,

which is now in the collection of the National Museum of Ireland). A notable exception to this trend in Adelaide was the German silversmith Julius Schomburgk who is thought to be the maker of a remarkable bangle with Australian motifs (pl. 9).

Among the first presentation testimonials made in Australia from local gold was, appropriately, the Hargraves Testimonial supplied by Thomas Hale, a Sydney retailer about whom little is known. Edward Hargraves was credited with the discovery of gold in 1851 and this cup was presented to him in 1853 as 'a public token of respect'. The piece had to be cast due to local silversmiths' inability to raise cups from a flat sheet of metal.

This skill came with the arrival of Hogarth,

Plate 8, page 16 **This bracelet and pendant are made in gold and cabochon garnet. Henry Steiner crafted the bracelet in Adelaide about 1860 and the pendant is attributed to C E Firnhaber, Adelaide, 1855. On the reverse of the pendant is the inscription: 'A farewell gift from Ladies of South Australia 1855.' It was presented to the wife of Governor Young of South Australia on her departure for Tasmania (Van Diemen's Land). Pendant H: 5.3 cm.**

Private collection

Plate 9 **Julius Schomburgk is attributed as the maker of this sculptural gold hinged bangle. It was produced in Adelaide about 1860. Unmarked. H: 6.1 cm.**

Lent by the Art Gallery of South Australia, Adelaide.

Gift of Miss Jane Peacock, 1945.

Erichsen & Co on the silversmithing scene in Sydney. Leading jewellers, they were also responsible for a group of major gold and silver presentation pieces. The earliest commission attributed to them is the

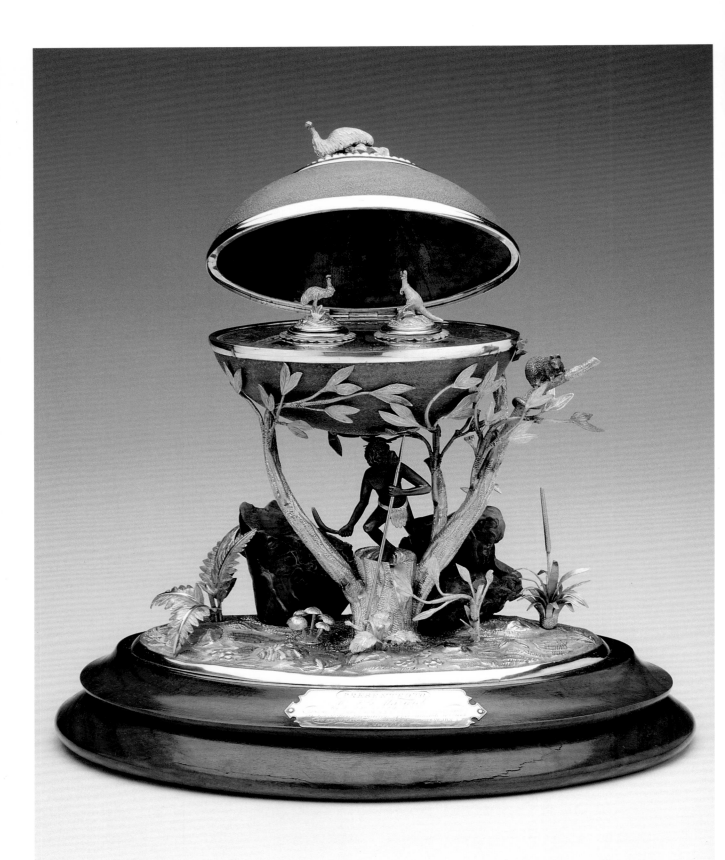

silver and myall-wood mace commissioned by Governor FitzRoy from the Sydney firm Brush and MacDonnell for presentation to the University of Sydney (established in 1850). This splendid piece was exhibited at the Paris Exhibition of 1855 together with a spectacular range of gold statuettes, cups, jewellery, medals and other items from Sydney and Melbourne. The display was a reflection of the country's new-found wealth and marked a change from Australia's contribution to the Crystal Palace Exhibition, which opened in May 1851, when it was reported that 'the colonies of Australia have nothing very new or showy to exhibit'.[11]

After 1861, Hogarth began working on his own. Among the most interesting objects he then produced was a wedding gift in the form of a casket presented in 1864 by the 'Ladies of New South Wales' to Princess Alexandra. Its design combines both classical reliefs after the Danish sculptor Bertold Thorvaldsen (Hogarth is believed to have studied under Thorvaldsen) and a plethora of Australian motifs. Hogarth may have also been responsible for the gold and silver inkstand supplied to the 1862 London Exhibition by the firm Flavelle Bros (pl. 13).

The fashion for silver mounting of the exotic ostrich egg flourished in Europe since at least the 16th century. Splendid goblets and even whole figures of ostriches incorporating imposing cream-coloured eggs were particularly fashionable in early 17th century Germany, and still enjoyed some popularity in 19th century Europe. It remains unresolved as to who among the early Australian silversmiths first mounted the smaller, dark-green emu egg, thus

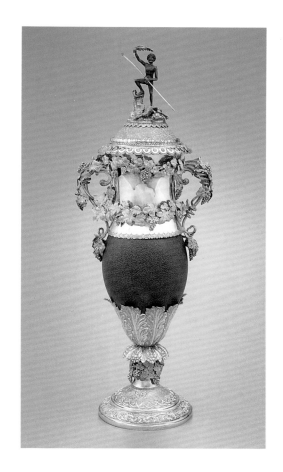

Plate 11 **This standing cup and its cover are made of silver, parcel gilt and emu egg by the silversmith Christian L Qwist in Sydney about 1865. H: 41 cm.**

Lent by the National Gallery of Victoria.

Gift of Mr W J Ward, 1963.

Plate 10, page 18 **The inscription on this inkstand reads: 'Presented to Mr J.G. Marwick by the Directors of the Pitt St Congregational Church & School Penny Savings Bank as a grateful recognition of his valuable services as Honorary Secretary For Eight Years, 17th May , 1870.' Adolphus Blau produced the piece in about 1870 in Sydney using silver, malachite and an emu egg. Unmarked. H: 23 cm.**

Private collection

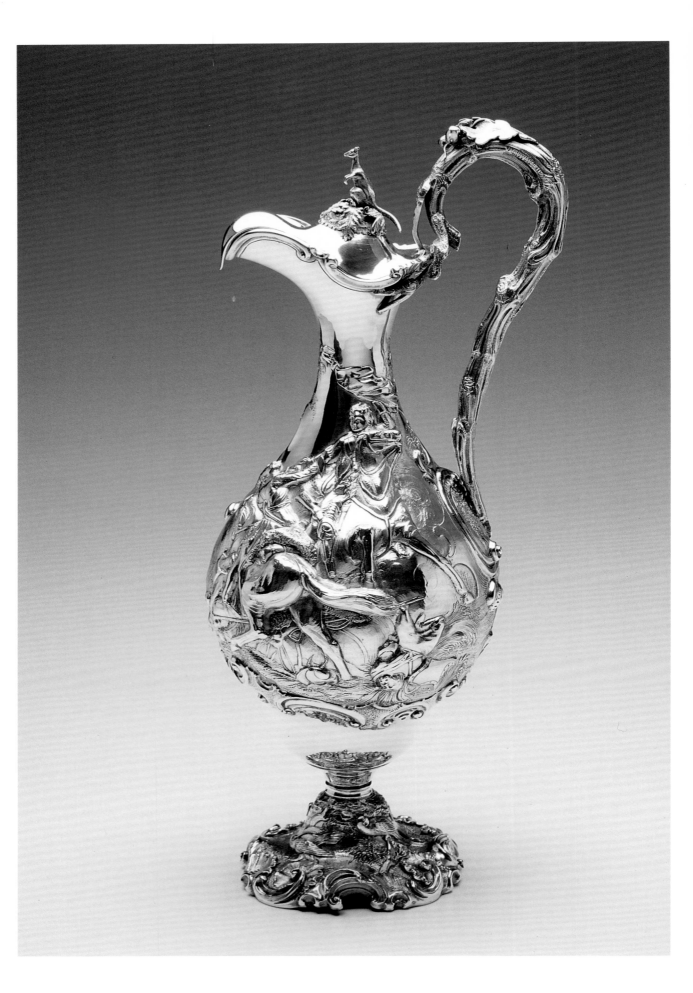

enriching the tradition and creating a distinctive form of Australian presentation silver. Emu egg cups have been produced in Australia since at least 1857. In Sydney, the silversmith Christian Qwist developed this idea in a most creative manner as evidenced in his trophies (pl. 11) and the magnificent ostrich egg claret jug of about 1865. A marvellous silver and malachite emu egg inkstand testifies to the talents of yet another early Sydney maker, the Hungarian-born jeweller, silversmith and gold exporter, Adolphus Blau.

The richest of all Australian colonies, Victoria attracted the greatest number of silversmiths. Among the most important was another Hungarian-born jeweller and silversmith, Ernest Leviny, who also

Plate 13 **A chromolithograph from *Masterpieces of industrial art and sculpture at the International Exhibition, 1862*, by J B Waring, London. It illustrates a gold and myall-wood inkstand *(top left)* made by Julius Hogarth or Christian Qwist for Flavelle Bros in Sydney in about 1862, and the Bruce inkstand *(centre)* made by Ernest Leviny in Castlemaine, Victoria, in about 1858. The gold sculptures of an emu and kangaroo were made by Hogarth.**

Plate 12, page 20 **A silver claret jug crafted in the workshop of William Edwards, Melbourne, about 1868. H: 43 cm.**

Lent by J B Hawkins Antiques.

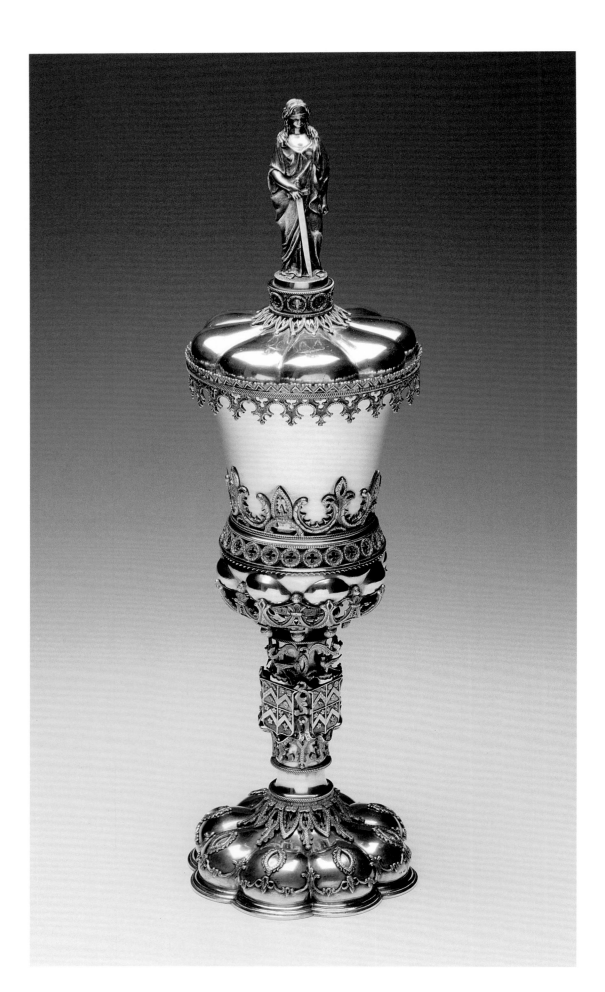

mounted some of the earliest emu egg cups. Trained in Vienna, Leviny practised in Paris and London before sailing for Australia in 1853 to try his luck on the goldfields. Unsuccessful in this endeavour, he established a jewellery business in Castlemaine which prospered until about 1865.

Very little of Leviny's gold and silver work survives. His best-known piece is the silver testimonial presented by prominent citizens of Castlemaine to Abraham Saint, the proprietor of the *Mount Alexander Mail*, on his departure from that town in 1863. Largely conceived in the renaissance revival style with a range of allegoric figures including an Aborigine and a gold digger, the Saint Testimonial is probably the most successful allegorical piece made in colonial Australia. Leviny's other tour de force, an elaborate rococo revival gold inkstand incorporating gold nuggets in its design, was presented in 1858 to J V A Bruce, the contractor of the Murray Bridge railway, by his workers. Unfortunately, it has probably been lost (pl. 13).

In Melbourne, William Edwards' workshop excelled in the production of emu egg trophies.[12] The son of a London silversmith, Edwards arrived in 1857 and soon became established as Melbourne's leading supplier of objects to major local retailers until about 1876. He is credited with making the earliest surviving mounted emu egg, the covered cup presented in 1859 to a Melbourne University scholar by his students. This cup is now in the collection of the Powerhouse Museum. More importantly, Edwards introduced a range of emu egg 'novelties' to Australian silver. His various cups and inkstands are usually supported on small silver tree ferns rising from octofoil bases embossed with emus, kangaroos and rocks or purely with floral decoration. Vertically or horizontally mounted, sometimes lacquered or even leather bound, these ingenious creations were in steady demand until the end of the century.

Although silver-mounted emu eggs form the largest surviving body of Edwards' output, his workshop also produced a number of silver and occasionally gold trophies and epergnes (table centrepieces) which secured him awards in international exhibitions and brought major commissions such as the gifts for Prince Alfred, Duke of Edinburgh. The majority of the firm's wares were designed in the naturalistic and rococo revival styles. From the early 1860s, classical revival motifs and forms began appearing, often in combination with rococo and sometimes gothic elements.

Among the most interesting examples of surviving work bearing Edwards' marks is the gold and silver inkstand made for presentation in 1865 to the Manchester businessman John Todd by Thomas Bibby Guest as 'a token of gratitude for the liberal assistance … to establish himself in profitable business' (pl. 54). Less spectacular, yet well-known examples of Edwards' presentation silver are the

Plate 14 **The silver Hanson Cup was presented with a matching salver to Sir Richard Davies Hanson in 1862. It was made by Charles E Firnhaber in collaboration with Julius Schomburgk in Adelaide about 1862. H: 54 cm.**

Lent by Dr Leonard and Phyllis Warnock.

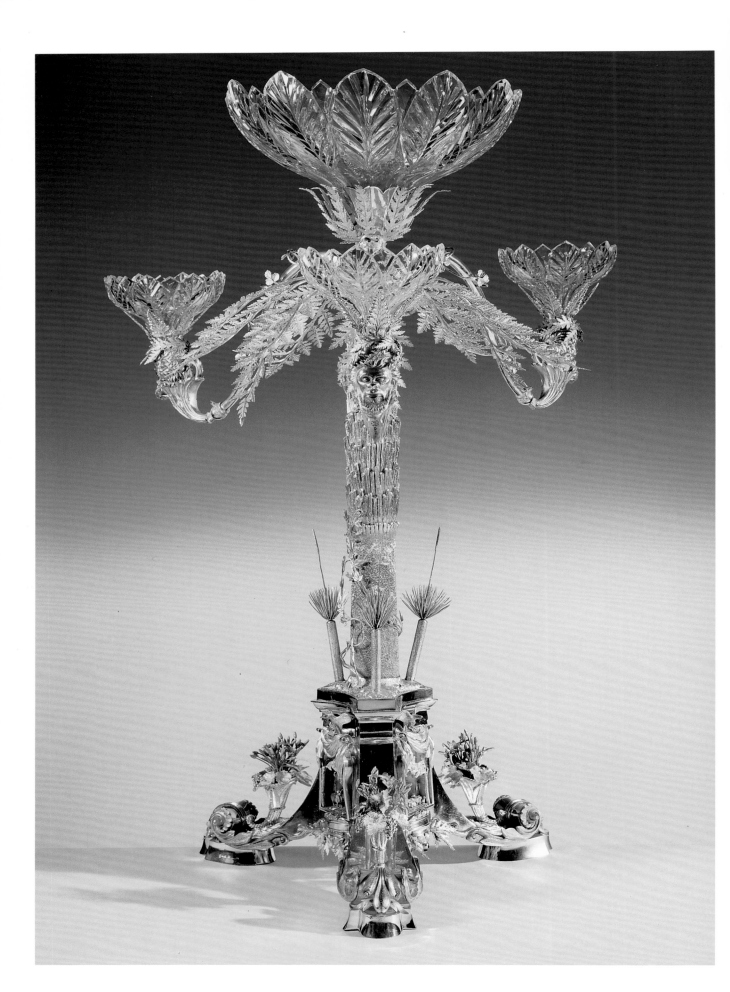

handsome claret jugs, often applied with a naturalistic vine leaf swag, produced during the 1860s.[13] Edwards' jugs proved very popular in Australia and were produced in many variations including richly *repoussé* pieces (pl. 12) and even emu and ostrich egg versions.

There was little gold discovered in South Australia, the first non-convict colony settled in 1836. It prospered, after a slow start, on the strength of rich copper deposits mined principally at Burra, Kapunda and Moonta. Silversmithing in this 'copper country' was dominated by craftspeople of German descent who settled in Adelaide. South Australia's early leading silversmiths were Charles Edward Firnhaber and Julius Schomburgk. They supplied a range of often sophisticated presentation pieces, which from the mid 1860s were mostly sold through the retailing firms of Henry Steiner and J M Wendt.

Firnhaber came to Australia in 1847 and soon commenced producing silver presentation cups and ecclesiastical plate of outstanding quality. Among the objects produced by him is a fine emu egg goblet made in the early 1860s, decorated with sculptural Australian motifs and flat silver scrollwork of a distinctively continental character. Today however,

Firnhaber is best known for the superb silver cup in the gothic revival style presented in 1862 to Sir Richard Davies Hanson, South Australia's Chief Justice. (pl. 14) Firnhaber made the Hanson Cup in collaboration with Julius Schomburgk who joined Adelaide's German community in 1850.

Schomburgk is believed to have been responsible for a series of emu and ostrich egg presentation cups, inkwells, candelabra and epergnes.[14] A committed exponent of Victorian naturalism and brother of a noted botanist, he incorporated in his designs a vast range of sculptural motifs representing Australian flora and fauna in combination with figures of Aborigines (pl. 41 and 43). Among the most spectacular examples of his larger scale work is the frosted silver John Ridley Candelabrum of 1860. Presented to the inventor of a reaping machine by colonists of South Australia, it is topped with a gold model of his invention (pl. 37). Another important object, made about 1864 for J M Wendt and never presented, is the Dunedin Centrepiece named after the International Dunedin Exhibition of 1864-1865 where it was first shown (pl. 15).

CONSOLIDATING THE TRADITION: 1870-1900

By 1870 Australia's population had reached over 1.6 million, an astounding increase from about 400,000 people who lived in the colonies in 1850.[15] The larger population meant greater opportunities for jewellers and silversmiths and the trade in both imported and locally made jewellery and silver was thriving. The majority of approximately twenty established firms, such as Flavelle Bros in Sydney, Kilpatrick & Co in

Plate 15 **The Dunedin Centrepiece crafted in silver and glass is attributed to Julius Schomburgk. It was made in Adelaide about 1864 for the retailer J M Wendt. Unmarked. H: 81 cm.**

Private collection

Photograph courtesy of J B Hawkins Antiques Reference Library.

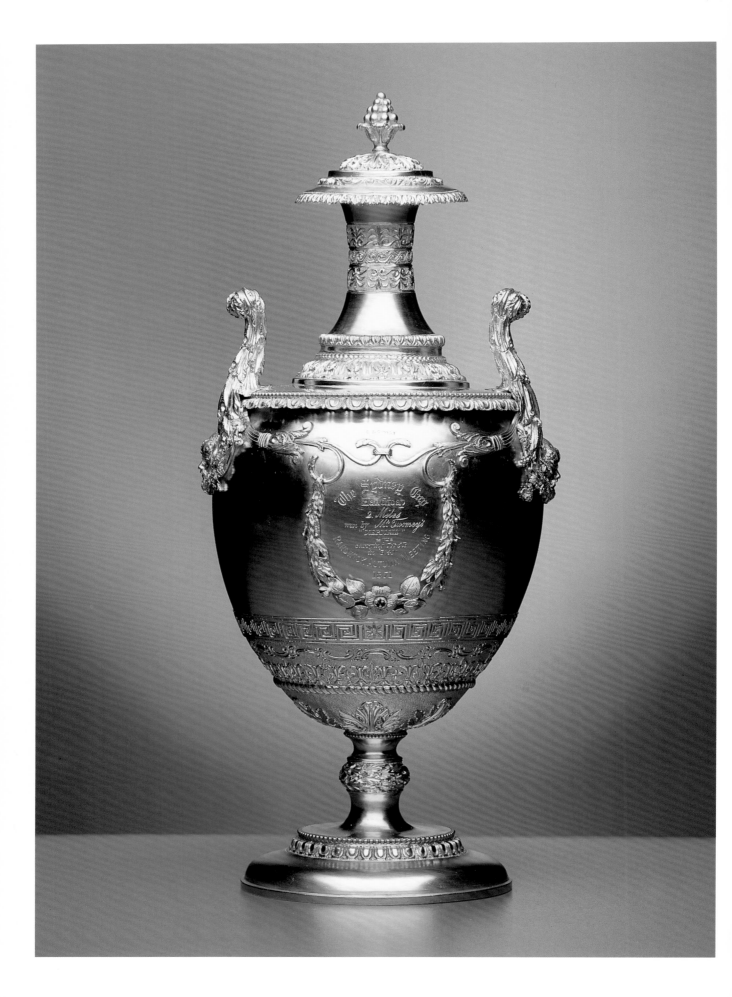

Melbourne and J M Wendt in Adelaide prospered and expanded. New businesses, including Evan Jones and William Kerr in Sydney, were established. Despite increased silversmithing activities in Queensland, most of the best quality work was still being produced in Sydney, Melbourne, Geelong and Adelaide.

Accomplished in goldfields and everyday jewellery and 'home' ornaments, jewellers and silversmiths now produced an increasing range of special pieces for presentation and display at the colonial and international exhibitions in London, Paris, Philadelphia, Dunedin, Calcutta as well as in Sydney, Melbourne and Adelaide.

Based on ideas introduced during the 1850s-1860s, jewellery decorated with Australian motifs continued to be successfully produced. In 1887, for example, Evan Jones showed in the Adelaide Jubilee Exhibition, 'Jewellery — Gold Quartz from Hill End …, mounted as brooches and ear-rings with Australian foliage gold mounts'.[16] Although gold rushes continued in the 1870s, the finds were smaller and the level of excitement had begun to diminish. Generally, jewellery was now less massive, showing a more restrained use of Australian flora and fauna motifs. Often the only hint at the origin of a brooch would be found in the tiny emus and kangaroos incorporated in foliate frames embracing an Italian cameo shell or a micromosaic. The mainstream Australian made jewellery of this period concentrated on the use of local gemstones and shells in designs that followed European fashions.

Australian opals, pearls and quartzes as well as mother-of-pearl, quandong seed and operculum (a valve of the mouth of a sea-snail shell) were used in gold brooches, earrings, necklaces and parures (sets of jewellery) by jewellers such as Hippolyte F Delarue and F Allerding and Son in Sydney (pl. 57) and J M Wendt and Henry Steiner in Adelaide.

During the last three decades of the 19th century Australian silversmiths manufactured a large number of presentation pieces and a range of silver and gold foundation trowels commemorating the construction of new public buildings. A substantial group of ecclesiastical commissions was executed, probably the most important being the magnificent gold crozier made about 1877 by the Sydney silversmith E J Hollingdale for presentation to The Most Reverend Roger Vaughan, Archbishop of Sydney. This period, however, was dominated by the production of sporting trophies, particularly for the flourishing racing scene in all colonies.

In 1866 the Australian Jockey Club held the inaugural Sydney Cup at the new Randwick course. The first cup presented to the owner of the winning horse was made in England and the trophies for the subsequent 1867 and 1868 races are not documented and probably have not survived. Christian Qwist, however, was responsible for manufacture of the magnificent gold cups awarded at the 1869, 1870 and 1871 meetings. Trained in Denmark, Qwist came to

Plate 16 **The gold Sydney Cup was made by Christian L Qwist in Sydney in 1871. It is inscribed: 'The Sydney Cup Handicap Two Miles Won by Mr Twomey's Mermaid.' H: 25 cm.**

Powerhouse Museum 94/223/1

Australia about 1852 and settled on the Victorian goldfields in Bendigo (then Sandhurst) where he worked as both commercial photographer and silversmith. There he executed a range of mostly gold commissions, including the seal for the Corporation of Sandhurst, none of which has survived.

After moving to Sydney in 1860, Qwist worked for Hogarth, Erichsen & Co then ran his own workshop until his death in 1877. Among his most significant orders in Sydney were the three Sydney Cups designed in the classical revival style with restrained chased and applied decoration. Particularly noteworthy is the 1871 cup won by the horse Mermaid and presented to its owner Edward Twomey at the Randwick Autumn Meeting (pl. 16). This well-proportioned and elegant cup in the form of a classical urn, now in the Powerhouse Museum collection, is arguably the finest surviving example of gold racing trophies made in 19th century Australia.

Another important Sydney silversmith, widely known for his sporting trophies was William Kerr who came from Northern Ireland in the early 1860s. After several years as a principal jeweller employed by Hardy Bros, he established his own business which after his death in 1896 was continued by his sons. The three silver trophies Kerr displayed in the Sydney International Exhibition of 1879, the racing trophy, the cricket trophy and the bowling trophy, illustrate his preference for Victorian naturalism and the use of Australian motifs. Probably the most impressive of the three pieces, the racing trophy in the form of an epergne, was presented by the mayor of Sydney to the Australian Jockey Club for the winner of a forthcoming meeting. It depicts an entire race course under a tree fern, with a miniature representation of a racing scene complete with a sailor, an Aboriginal figure and examples of Australian fauna. Similar in concept is the cricket trophy with the miniature cricket field and two emu eggs prominently featured in the design (pl. 50). Probably inspired by the success of the Australian team's 1878 tour of England and reported in the press as representing the 'All England Eleven', it was never presented.[17]

As major sporting trophies, Kerr centrepieces decorated with native motifs are rare in Australian silver. In the colonies the most popular sports were firmly rooted in British culture, and designs for sporting trophies mostly emulated English models. The victories of Australia's cricket team contributed to the emergence of national sentiment and confidence. The fact that even sporting silver was now proudly decorated with indigenous forms and motifs can be interpreted as evidence of an emerging national identity.

Evan Jones, a renowned Sydney silversmith, successfully continued the tradition of silver-mounted emu eggs from the 1870s until, at least, the end of the century (pl. 52). A former apprentice of Hogarth, Erichsen & Co and subsequently of Qwist, he was frequently represented in colonial and international exhibitions. It was reported, for example, that in the Sydney Exhibition of 1879, he showed 'emu's eggs ... mounted in 101 different ways'.[18] Jones was also a prolific jeweller, an accomplished medallist and maker of rowing and sculling trophies and large testimonials with

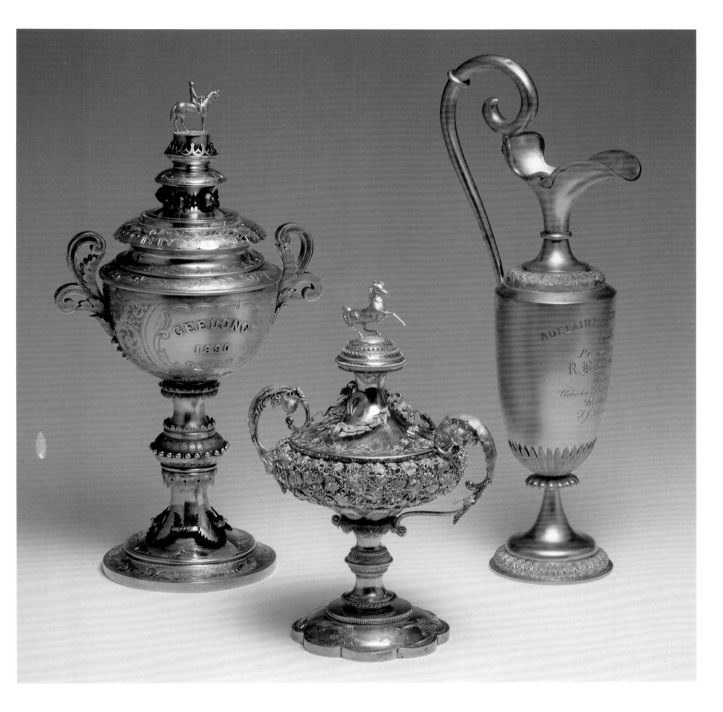

Plate 17 **Gold presentation cups *(from left to right)*: The 1890 Geelong Cup, Edward Fischer, Geelong, 1890. H: 35 cm.** Lent by Rare Art (London) Ltd.
The 1874 Geelong Cup, Edward Fischer, Geelong. H: 25 cm. Private collection.
The 1881 Adelaide Hunt Club Cup, Henry Steiner, Adelaide. H: 38 cm. Lent by Rare Art (London) Ltd.
Photograph courtesy of J B Hawkins Antiques Reference Library.

Australian motifs. His modelling skills in silver can best be appreciated in the marvellous sculptural inkwell in the form of a sitting emu made about 1875 (pl. 53).

Gold-rich Victoria was the centre of Australian racing from the 1850s and in 1873 the Victoria Coursing Club was founded. The jeweller and silversmith who excelled in the manufacture of

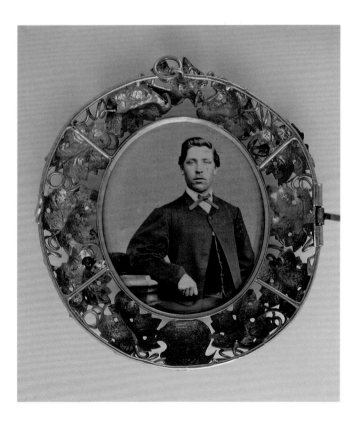

sporting trophies in Victoria in the 1870s and 1880s was Edward Fischer of Geelong. Trained in Vienna, Fischer arrived in Australia about 1851. He had a large, prospering jewellery business in the 1870s where 'every kind of work ... in the gold and silversmiths art [was] executed'.[19] Fischer's workshop was also responsible for most of the silver and gold sporting trophies ordered in later 19th century Victoria, which were executed to designs of the noted colonial artist Frederick Woodhouse senior. Fischer is probably best known for his series of gold cups for the Geelong races from 1873 to 1890, of which it seems only five remain (pl. 17). The surviving cups, original designs as well as descriptions of other pieces in contemporary newspaper reports confirm Woodhouse's reliance on international styles. He mostly drew on classical forms which he decorated with applied naturalistic foliage and intricate engravings. Woodhouse's designs also revealed rococo and renaissance revival influences.

In Adelaide, the sporting scene was almost as busy, and the Adelaide Cup was now run at the new course at Morphettville. Supply of sporting and other presentation trophies in this colony was largely in the hands of the leading firms, J M Wendt and Henry

Plate 18 **This brooch/pendant made in gold, glass and paper features Australian motifs on one side and is fitted with a photograph of a young man taken by a Melbourne photographer on the other** (pl. 19). **It was made in about 1870, the maker is unknown.**

Powerhouse Museum 94/156/1

Steiner. Born in Denmark, Jochim Matthias Wendt came to Australia in 1854 thus beginning his career of approximately thirty years as a leading retailer and manufacturer of jewellery and silver; the firm is still trading today. Although many of J M Wendt's earlier commissions were probably designed and executed by Schomburgk whom he employed, it appears that from about 1870 Wendt himself was the principal producer. (pl. 44 and 46) Among the firm's most interesting works is the silver model of *The Block 10 Mine*, the richest silver mine in Broken Hill where silver-lead ore was first discovered in 1875. Complete with miniature shafts, tunnels and working miners, the model was presented in 1892 to the manager of the Broken Hill Block 10 Company by its shareholders in recognition 'of his fidelity ... during the arduous and anxious period of the memorable strike among the Barrier miners' (pl. 21).

Henry Steiner, a German immigrant, was one of the most prolific jewellers and silversmiths in Adelaide between 1864 and 1884, when he sold the business to August Brunkhorst, another German-born jeweller and silversmith. It appears that Steiner collaborated with Firnhaber and some objects stamped with Steiner's mark might be attributed to him. Unlike Wendt's gold and silver horseracing trophies which today are known only from press reports, a substantial number of sporting presentation pieces by Steiner have survived. Particularly attractive is the group of gold and silver claret jugs made in the 1880s and designed in the classical revival style (pl. 17). Many of these elegant trophies were originally purchased and presented to Adelaide sporting clubs

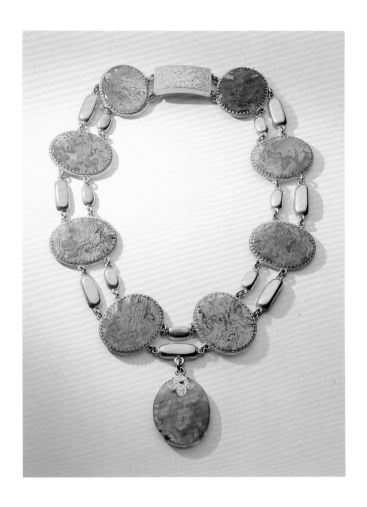

Plate 20 **The jeweller Henry Steiner made this necklace of moss agate and gold in Adelaide about 1880. D: 16 cm.**

Private collection

by Robert Barr-Smith, a wealthy South Australian businessman.[20] Steiner's workshop also produced outstanding jewellery (pl. 20 and 55), presentation caskets, sculptural pieces (pl. 47), and large epergnes with Australian motifs which were regularly displayed at colonial and international exhibitions. Together with Wendt, Steiner continued to mount emu eggs in the form of claret jugs, cups, inkstands and perfume bottle holders (pl. 42).

Towards the end of the century, Australian silversmiths, always keen to keep abreast of

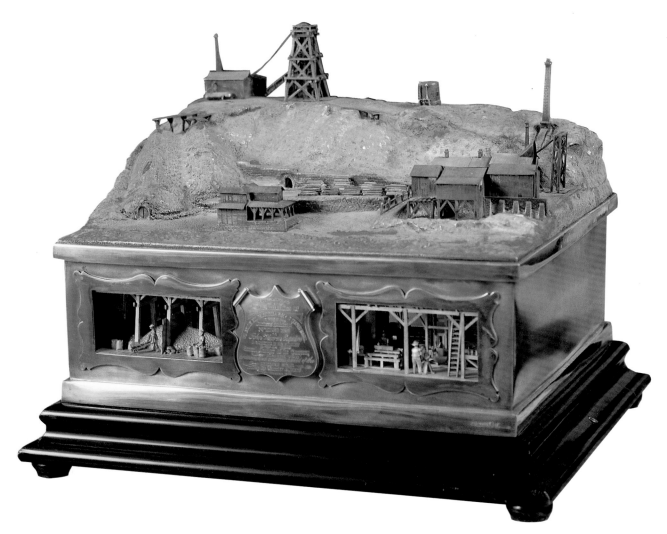

Plate 21 **Silver model of the *Block 10 Mine* made by J M Wendt in Adelaide about 1892. It is inscribed: 'Presented by the shareholders of the Broken Hill Proprietory Block 10 Company Limited in terms of their unanimous resolution of November 24th, 1892 to John Warren, Esquire in recognition of his fidelity as General Manager of the Company during the arduous and anxious period of the memorable strike among the Barrier Miners, July–November 1892.'**

H: 30 cm.

Lent by the Broken Hill Historical Society Inc (Silverton Gaol Museum).

Photograph courtesy of J B Hawkins Antiques Reference Library.

international developments, began to introduce elements of the fashionable art nouveau style into their work. Jewellers, however, continued to develop an indigenous style, stimulated by further gold finds.

With the discovery of one of the world's richest goldfields in Western Australia thousands rushed to this colony. Once again, jewellers were busy making goldfields jewellery for the successful miners and for sale as gifts and souvenirs. Western Australian brooches developed their own character evidenced by their simpler designs, generally smaller scale and a focus on selected motifs – predominantly mining equipment. The brooches were frequently designed in the form of crossed picks and shovels applied with small nuggets and tiny buckets swinging freely below

the composition. The more elaborate examples incorporated names of places of lucky strikes or goldmines (pl. 25). Also popular were bar-brooches decorated with nuggets or swans, the heraldic emblems of this colony.

Although the design of Australian gold and silver of the late 19th century was influenced by English and European models, Australian silversmiths also developed a unique style in jewellery and presentation pieces. In their own time, the elaborate brooches and bracelets, the magnificent emu egg inkstands, cups and centrepieces were treasured by their recipients, awarded prestigious prizes in intercolonial and international exhibitions and were highly acclaimed in the press. Today, these rare and often highly original time capsules of Australia's decorative arts and social history continue to play an important role as tributes to the skills, achievements, beliefs and customs of people who lived in and shaped Australia's 'golden' epoch.

Eva Czernis-Ryl is a curator of decorative arts and design and the Australian gold and silver, 1851–1900 *exhibition.*

Notes

1. The term silversmith, as used in this book, indicates a worker both in silver and gold.
2. Letter by W Maum, 26 May 1806, *Historical records of New South Wales*, vol 6, pp 76-77, Government Printer, Sydney, 1898. Also, *Historical records of Australia*, Series I, vol 5, p 812, The Library Committee of the Commonwealth Parliament, 1915.
3. J W James, 'Australian silver, the origins', *The Australian Antique Collector*, July-December 1984, pp 46-49.
4. R Therry, *Reminiscences of thirty years' residence in New South Wales and Victoria*, Sampson Low, Son & Co, London, 1863, pp 40-41.
5. M R Sainty, K A Johnson, *Census of New South Wales, November 1828*, Library of Australian History, Sydney, 1985.
6. J B Hawkins, *Nineteenth century Australian silver*, Antique Collectors' Club, Suffolk, England, 1990, pp 53, 58-60 (illus). Hawkins states that the chalices were made by Alexander Dick who worked for Robertson from 1824 to 1826.
7. Forrester received his ticket of leave in 1839 and then worked for himself in Tasmania before departing in 1846 for Melbourne where he was employed by Charles Brentani, an Italian silver retailer. See Hawkins, vol 2, pp 208-213.
8. The salver bearing the marks of the Sydney retailer J J Cohen and presented to James Simpson in 1842, a retiring Court officer in Melbourne, is also thought to have been made by Forrester and supplied by Barclay from Hobart. See Hawkins, pp 219-291.
9. Mrs Alan Macpherson, *My experiences in Australia, being recollections of a visit to the Australian Colonies in 1856-7*, Hope, London, 1860 p 324.
10. The official title of the exhibition was *The natural and industrial products of New South Wales*. It was organised by the 1855 Paris Exhibition Commissioners and shown at the Australian Museum in Sydney in November 1854, prior to the Paris Exhibition.
11. *Illustrated London News*, 3 May 1851.
12. Hawkins hypothesises that Edwards employed Ernest Leviny and Christian Qwist as outworkers between 1858 and 1860, using and marketing their ideas for silver-mounted emu eggs.
13. A very similar jug was supplied by the London retailing firm of Widdowson and Veale for display in the Great Exhibition of 1851. See *Illustrated London News*, 3 May 1851.
14. Hawkins, vol 2, pp 35-48.
15. *The Australian Encyclopedia*, The Grolier Society of Australia, Sydney, vol VII, p 190.
16. A Schofield, K Fahy, *Australian jewellery, 19th and early 20th century*, David Ell Press, Sydney, 1990, p 205.
17. *Sydney Daily Telegraph*, 25 September 1879.
18. *Sydney Daily Telegraph*, 25 February 1879.
19. 'A peep into a working jeweller's shop', *Geelong Advertiser*, 8 March 1876.
20. C Menz, *Colonial Biedermeier and German art in South Australia during the 19th century*, Art Gallery Board of South Australia, Adelaide, 1992, p 15.

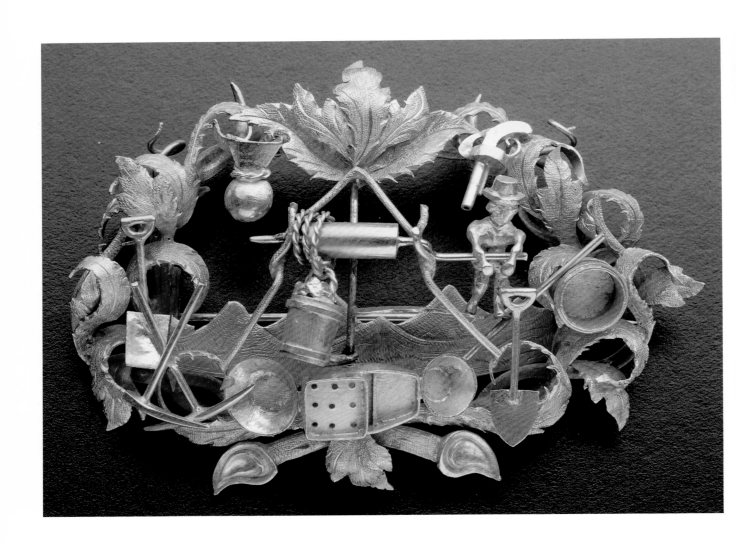

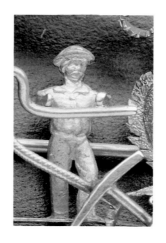

golden memories

EDDIE BUTLER-BOWDON

The material culture of the goldfields provides a unique way to approach the history of the Australian gold rush. In particular, the goldfields brooches represent life and wealth on the goldfields. The more intricate brooches (see pl. 22 and 24) present detailed tableaux, the components of which — the digger, the nugget, the windlass, the pistol and the floriate border — will be used as markers for this historical sketch of gold-rush Australia.

THE BROOCH AS TABLEAU

The goldfields, or diggers', brooches were a popular purchase and commission in 19th century gold-rush Australia. Within an heraldic form, the brooches depicted how, with the crank of a windlass, the gold digger on his own was able to legally pluck a bucket-sized nugget from a hole in the ground. Eureka! Lest it all looks too easy his tools of trade were there to confirm his resourcefulness and savvy — a pick, shovel, pans, a cradle, even a pistol. All was wrought in pure gold. The message was the medium.

The goldfields brooches celebrated an idealised view of what it was to be a gold digger, or Argonaut as they were romantically called. The brooches were commissioned by those who sought to bestow a memento of their success on a sweetheart or wife. The most elaborate examples emanate from the early years of the gold rushes when the alluvial, or surface gold, was comparatively easily won. Not surprisingly, nuggets invariably took a central place in their composition. Later brooches from the Western Australian goldfields of the 1880s and 1890s, where the individual miner had less success, tend to be simpler although a replica of the whole nugget was usually incorporated in the design (pl. 25). Generally, brooches and other pieces of jewellery made in the 1880s followed the current fashion and were smaller than the large, heavy jewellery so popular in the 1850s.

THE GOLD DIGGER

The image of the gold prospector, alone or with a couple of mates, hard at work or play, dominates the iconography of gold-rush history. He has been romanticised, eulogised and replicated in every medium, from the brooches, to watercolours and later, photographs. As a social type, the individual gold digger was unheard of before the mid 19th century. Although the European exploration and exploitation of the Americas from the 15th century was driven by gold, its acquisition was mostly to contribute to the greater wealth and glory of European monarchs and the Roman Church. Similarly, the Russian finds of the mid 1800s were the property of the Tsar.

What made California and Australia different was capitalism. The right of the individual to free

Plate 22, page 34 A diggers' or goldfields brooch made up of component parts about 1855. The maker is not known; today only a few pieces of Australian goldfields jewellery of this period have a provenance that permits attribution to a particular maker. W: 8.5 cm.

Powerhouse Museum A9876

Plate 23, page 35 Detail of diggers' brooch (see plate 24, page 37).

Powerhouse Museum A4478

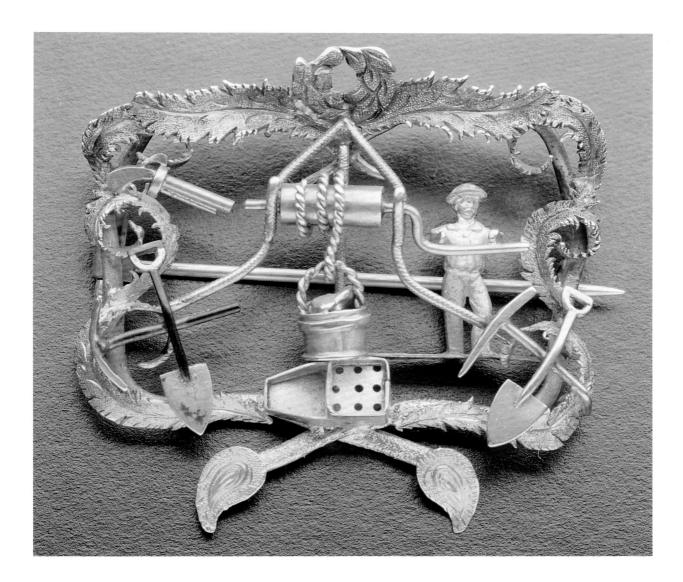

Plate 24 **The diggers' brooch commissioned by Edward Austin of Bathurst for his wife Mary Ann, unknown maker, about 1855. W: 4.6cm.**

Powerhouse Museum A4478

movement and the acquisition of wealth was central to the laissez-faire notions which were fundamental philosophies for the United States of America and the British Empire. Many contemporary commentators felt that the timing of the gold finds was ordained by Providence. This view, which rested heavily on the presumption of cultural and racial European superiority, was more complex than it may appear. It took in notions of imperial aggrandisement and economic rationalism to argue that the people of the Old World had reached a level of development which enabled them to exploit the God-given riches of the New World. Gold was seen less as a commodity,

however, than as wealth itself. In Sydney the position was expressed by local merchant T S Mort at a dinner held in 1853 to celebrate the anniversary of the discovery of gold: 'Gold is the mainspring of commerce, commerce is the forerunner of civilization; and civilization is the handmaiden of Christianity.'[1]

The notion of gold seeking epitomised the view of Australia as a *terra nullius* where wealth was 'up for

grabs'. In the United States the right of 'finders keepers' was written into the Constitution. In Australia it was given more grudgingly, under pressure and for the cost of a licence.

The discovery of gold occurred at a moment in history when transport and communication were at a level of development which encouraged the excitement that greeted the finds. In Britain especially, the wide availability and immediacy of cheap newspapers and magazines, each trying to outdo the other for hyperbole and wild speculation, created a unique culture of excitement. Transport, however, was still slow and there was a strong sense that if one did not immediately 'Race to the Gold Diggings' (as the name of a board game popular in England in the 1850s suggests) all the gold would be gone. Furthermore, there was a sufficient technology base to develop mining machinery which could sustain a gold industry in areas where the initial rush quickly exhausted the easily won gold.

It is well-known that several gold finds were made and publicised before Edward John Hargraves went to Ophir, near Bathurst, in May 1851. But in terms of gold production and its impact on the colonial economy and population the significance of that date is indisputable. Following Hargraves' discovery, the rush for gold became an astonishing spur to migration. The non-Aboriginal population of the colonies rose from 437,665 in 1851 to 1,151,947 in 1861. Twenty years later it had doubled and by Federation in 1901 it stood at 3,773,801.[2]

THE NUGGET

Gold hit the economy of the colonies like a thunderbolt. *(See map of major gold discoveries, page 45.)* In 1850, Gross Domestic Product was valued at 11.7 million pounds. Two years later it had tripled to 30.2 million pounds; before the decade was over it had doubled yet again to 61 million. By 1888 it was 194 million. Until the late 1860s the gold mining industry was the star performer. Then from about 1870 to 1890, the pastoral and agricultural sectors, followed by construction and manufacturing, reasserted themselves. However, towards the end of the century gold had resurged. The combination of the finds in Western Australia and the negative impact of the 1890s Depression on other economic sectors saw the gold industry once again rise to pre-eminence. The decade 1900 to 1910 was Australia's most productive since European settlement. From the late 1880s the silver mining industry also boomed for the first time. Until then most silver was produced as a by-product of gold mining.

Although there were sizeable gold finds in the interim – Palmer River in 1873 and Charters Towers in 1886 – the Western Australian finds precipitated the biggest gold rush since the 1860s. By then gold mining had become a capital-intensive industry in the eastern states. Most participants were employees of mining companies, substituting a Miner's Right for a pay packet. The Western Australian fields were the last great hope for the individual miner. Few prospectors, however, met with much success because there were too many of them and not enough alluvial gold (pl. 26).

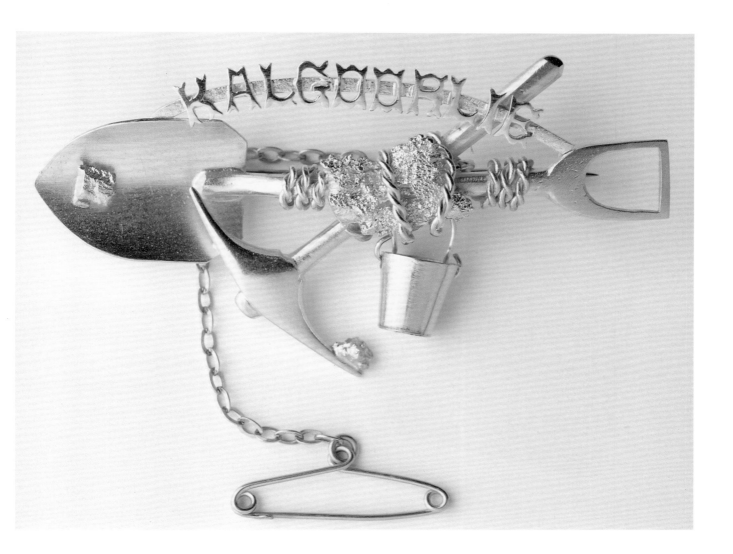

THE WINDLASS, THE CRADLE & PICK & SHOVEL

Given the value of gold it is not surprising that technology was developed very quickly to work new types of deposits and to rework the old ones. In early 1851, the windlass was already known in Australia as it had been in use in the mid 1840s at the copper mines of Burra, north of Adelaide, but the pan and cradle were not. Like much of the mining technology of later years they were imported from California in 1851. They were cheap to buy, portable and because they worked on gravity to separate the gold, cost nothing to use. Together with a pick and shovel, gold diggers found this technology adequate for working alluvial deposits.

Plate 25 **Reflecting the current fashion in jewellery and the paucity of easily won gold, brooches from the Western Australian goldfields of the late 1800s tend to be smaller. Nuggets are usually prominent, however. This gold brooch was crafted by an unknown maker, Western Australia about 1895. W: 5.5cm.**

Private collection

Alluvial gold, always quickly exhausted once a find became known, was found in creekbeds. Deep alluvial gold was mined from former underground watercourses. Diggers soon discovered that as their claims were so small, usually just a few square metres,

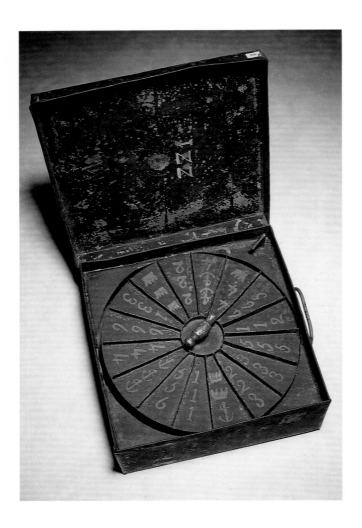

Plate 26 **This gaming box was used to play 'Crown and Anchor' on the Western Australian goldfields, about 1890.**

Powerhouse Museum 94/186/1

they had to band together to work these deposits. One man might work the windlass, two might dig below, two more might work the cradle. As leads became even deeper more capital-intensive technology was introduced. First horse power then steam were adapted through a variety of machines to remove the ore, pumping out water and then separating the gold. During this time mining companies were growing larger and there was often friction with groups of miners organised on cooperative lines.

Then came quartz reef mining. This involved digging more deeply and extracting the rich quartz then smashing it to unlock the gold within. The earliest quartz reef mines date to the late 1850s and by 1865 some mines were reaching depths of up to 200 metres. The use of steel cables and the development of explosives and drills enabled miners to dig more deeply and retrieve the gold-rich quartz. But the key piece of technology was the steam-powered quartz crusher (pl. 27). It became a symbol of the later years of mining when investors, promoters and company men took centre stage. The stock market floor rather than the goldfields became the site of the most frenzied activity. As early as 1861, one Melbourne newspaper sought to explain that those who were 'uninitiated in the most ordinary mining pursuits have nevertheless ... freely advanced their capital in mining ventures'.[3]

From the first gold rushes it was often the merchants who prospered and fared better than the average miner. Later, as the role of capital became increasingly essential to gold mining, the people who made the most money never handled anything other than paper. Edward Austin, as a prosperous Bathurst merchant and land speculator, was ideally placed when the gold rush struck. He built an even greater fortune by lending diggers the money to buy his equipment and then purchasing their gold. It seems the only time Austin touched a shovel was when he passed one over the counter. To Edward Austin it mattered little that he was not a miner, he still celebrated the source of his wealth with a digger's

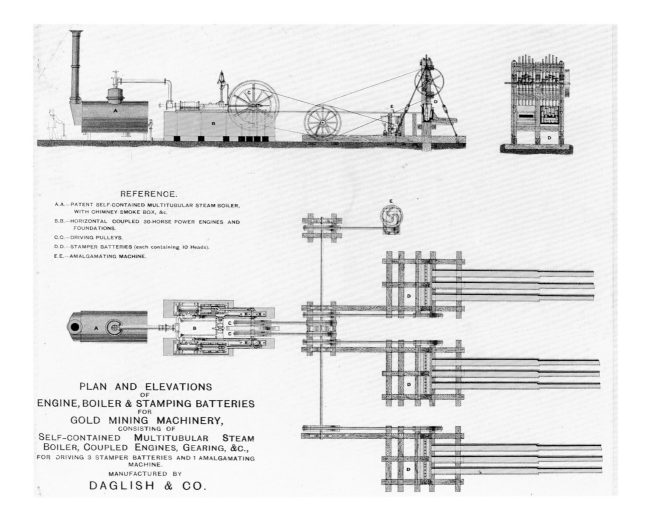

REFERENCE.

A.A.–PATENT SELF-CONTAINED MULTITUBULAR STEAM BOILER,
 WITH CHIMNEY SMOKE BOX, &c.
B.B.–HORIZONTAL COUPLED 30-HORSE POWER ENGINES AND
 FOUNDATIONS.
C.C.–DRIVING PULLEYS.
D.D.–STAMPER BATTERIES (each containing 10 Heads).
E.E.–AMALGAMATING MACHINE.

PLAN AND ELEVATIONS
OF
ENGINE, BOILER & STAMPING BATTERIES
FOR
GOLD MINING MACHINERY,
CONSISTING OF
SELF-CONTAINED MULTITUBULAR STEAM
BOILER, COUPLED ENGINES, GEARING, &C.,
FOR DRIVING 3 STAMPER BATTERIES AND 1 AMALGAMATING
MACHINE.
MANUFACTURED BY
DAGLISH & CO.

brooch which he commissioned for his wife Mary Ann in about 1855 (pl. 24).

Austin was a convict made good. The gold rush furthered his transformation from a potential subject of scorn and condemnation to one of admiration and even envy. Likewise, the image of Australia as a penal colony had to make way for Australia as the new El Dorado.

THE PISTOL

Old colonists were alarmed by the initial influx of gold-rush emigrants. Writing in 1852 under the pseudonym 'Colonus', Victoria's Chief Justice Sir William a'Beckett expressed grave concern for what would become of the colony's 'moral and thoroughly

Plate 27 **The quartz crusher, or stamper battery, became a symbol of the later years of gold mining when capital investment became increasingly essential to profitable mining.**

Powerhouse Museum 94/237/1

British population'.[4] Of course, neither Victoria or New South Wales had been 'thoroughly' any national group since the European invasion. But in a sense 'Colonus' need not have worried. The proportion of the non-Aboriginal population in Australia who were born here or in the British Isles never fell below 85 per cent for the remainder of the 19th century. Indeed, the power structure within the Australian colonies stayed predominantly 'British' and it was others,

Plate 28 **Gold changed white Australia's view of the economic landscape. This pastoral scene (detail) is captioned, 'Character of diamond bearing country near Copes Creek, Inverell.'**

Powerhouse Museum 95/34/1

notably the Aboriginal people and the Chinese miners, who suffered for it — often violently.

Among the national groups who came to Australia it was the Chinese who were systematically discriminated against by law.[5] About 40,000 Chinese miners arrived between 1856 and 1880. Entry restrictions, poll taxes and gold export taxes were levied on the Chinese people alone; and some goldfields officials did their best to make life difficult for them. Even these impositions were not enough for those Europeans whose notion of a 'fair go' did not include Chinese diggers. The Lambing Flat riot of June 1861, which saw the Chinese encampment burnt, is only the best known of many murderous attacks.

For the Aboriginal people gold discoveries meant that they were further dispossessed of their land. This was exacerbated by the rapid population growth that accompanied the gold rushes. In Victoria, where the non-Aboriginal population increased seven-fold from 77,345 in 1851 to 538,628 just ten years later, the impact of the gold rushes on the Aboriginal population was most severe. Low birth rates and high infant mortality, the result of venereal and other introduced diseases, devastated people who only a generation earlier lived without European intrusion.[6] By 1859 many gold-rush areas reported that there were no longer any Aborigines living locally.

Only in regions where the pastoral economy was desperate for workers was there a measure of respite. The dearth of labour on pastoral runs — 'Colonus' complained bitterly about the shepherds deserting their posts for diggings — encouraged pastoralists to employ Aboriginal workers. Blankets and food, rather than cash, were the most common payment.

THE FLORIATE BORDER

Observers often commented on the damage wrought by diggers. No one would ever have suggested they be restrained, however. For the most part, the landscape was viewed purely in economic terms. Gold mining, in fact, did much to redefine notions of the economic landscape. Previously, the country had been viewed solely in terms of its pastoral or agricultural potential. Mineral deposits provided a new hierarchy of value. In plate 28 the two are brought together in a photograph of a charming pastoral scene with the caption, 'Character of Diamond-bearing Country near Cope's Creek, Inverell, N.S.W.'

The early gold diggers' brooches were usually set within floriate frames. In some cases the

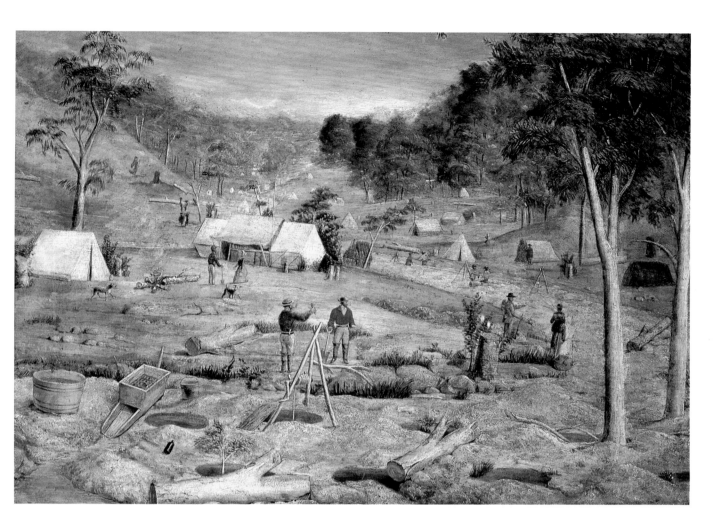

Plate 29 ***Mining camp at Bathurst*, attributed to E Tulloch, about 1855, oil on canvas.**

Reproduced courtesy Dixson Galleries, State Library of New South Wales.

commissioning digger may have developed an affinity with the landscape but more likely, it was a boastful reference to the exotic terrain in which he worked.

Miners showed little appreciation of the environment which surrounded them. This is expressed, albeit unintentionally, in the brooch in plate 22 where one can see mullock heaps at the digger's feet. Apart from the frame, the scene is denuded of vegetation. For the miner, no doubt, mullock heaps symbolised hard work. Although they pock mark the gold-rush landscape to this day, they were not as damaging as the ravages of mechanised extraction methods. Even more insidious damage was caused to vegetation and waterways by the run-off of mercury used in the separation process (pl. 30).

THE BROOCH AS MEMENTO

Interestingly, history has remembered the gold digger largely as he sought to memorialise himself. Gold, it could be argued, has occupied a suprisingly consistent place within the European imagination throughout modern times. The tableaux presented in the brooches are wholly consistent with present-day idealised views of what it was to be a gold digger, views which show no sign of withering. It remains easier, and probably more fun, to discuss gold-rush Australia in

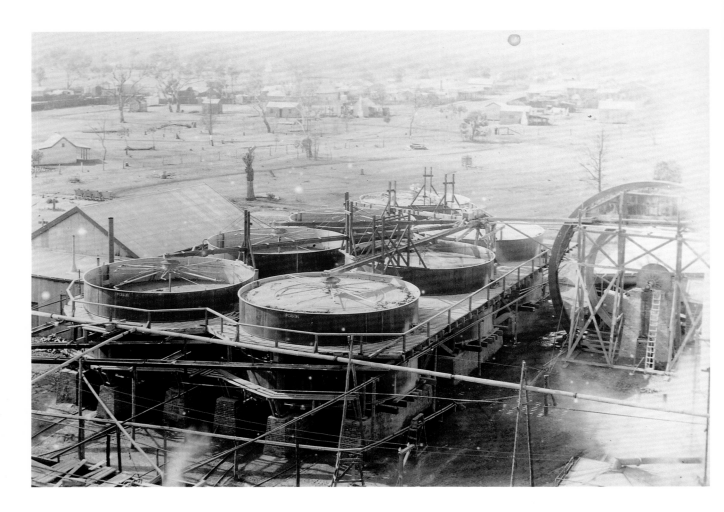

relation to its iconography rather than attempt to create an alternative reality.

Eddie Butler-Bowdon is a curator of social history

Notes

1. Quoted in D Goodman, *Gold seeking: Victoria and California in the 1850s*, Allen & Unwin, Sydney, 1994, p 33.

2. All statistics from *Australian Historical Statistics*, Sydney, 1987.

3. William Morgan Brown, 'The economy of quartz mining', *Mount Alexander Mail*, 1861, reprinted in *Gold fields of Australia: notes on the distribution of gold*, fourth edition, 1861.

4. 'Colonus', *Does the discovery of gold in Victoria viewed in relation to its moral and social effects . . .* , Benjamin Lucas, Melbourne, 1852.

5. Eric Rolls, *Sojourners: flowers and the wide sea*, chapter 3, 'Gold and tin', University of Queensland Press, St Lucia, 1993.

6. Goodman, *Gold seeking*, pp 17-20.

Plate 30 **The caption on this photograph reads, 'Cyanide vats and tailings wheel, Mt Boppy Gold Mining Co. NSW.' The run-off from chemicals used in the gold separation process was particularly detrimental to the local environment.**

Powerhouse Museum P2364

Major Australian gold discoveries, 1851-1900

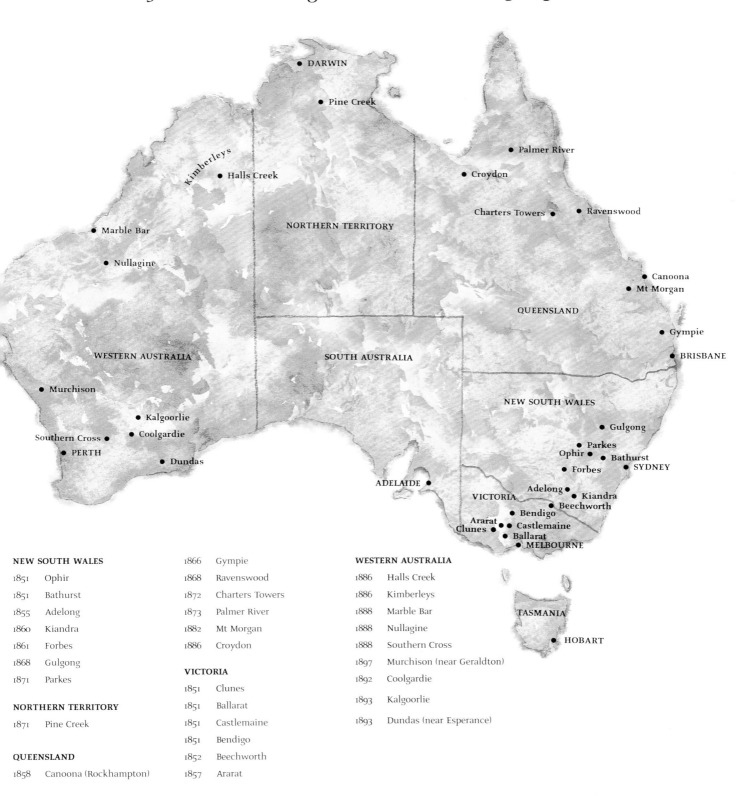

NEW SOUTH WALES

1851	Ophir
1851	Bathurst
1855	Adelong
1860	Kiandra
1861	Forbes
1868	Gulgong
1871	Parkes

NORTHERN TERRITORY

1871	Pine Creek

QUEENSLAND

1858	Canoona (Rockhampton)
1866	Gympie
1868	Ravenswood
1872	Charters Towers
1873	Palmer River
1882	Mt Morgan
1886	Croydon

VICTORIA

1851	Clunes
1851	Ballarat
1851	Castlemaine
1851	Bendigo
1852	Beechworth
1857	Ararat

WESTERN AUSTRALIA

1886	Halls Creek
1886	Kimberleys
1888	Marble Bar
1888	Nullagine
1888	Southern Cross
1897	Murchison (near Geraldton)
1892	Coolgardie
1893	Kalgoorlie
1893	Dundas (near Esperance)

The state and territory boundaries shown on this map are present day.

The information was compiled with the assistance of the Sovereign Hill Gold Mining Township, Ballarat.

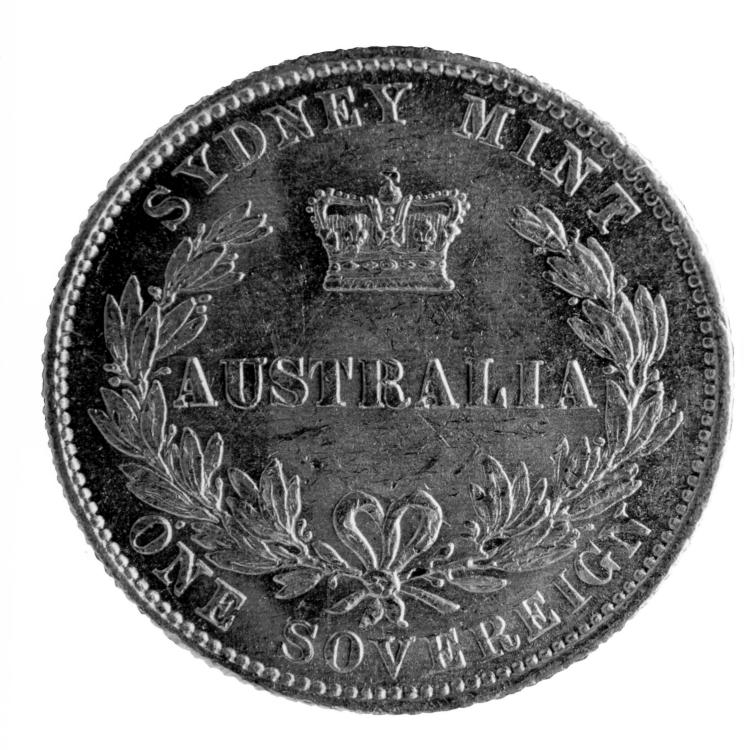

mints, metals and meaning

DAVID DOLAN

All my life I have been in love. I have been in love with gold. I love its colour, its brilliance, its divine heaviness. I love the texture of gold, that soft slimness that I have learnt to gauge so accurately by touch that I can estimate the fineness of a bar to within one carat. And I love the warm tang it exudes when I melt it down into a fine golden syrup. But above all, Mr Bond, I love the power that gold alone gives to its owner — the magic of controlling energy, exacting labour, fulfilling one's every whim and, when need be, purchasing bodies, minds and even souls ... I ask you, is there any other substance on earth that so rewards its owner?

Auric Goldfinger in *Goldfinger* by Ian Fleming[1]

Goldfinger's attitude has been widespread. Until the 20th century, ownership of mines and hoards of precious metals were critical measures of a ruler's power. Kings and armies fighting and colonising for treasure have caused innumerable wars and killings over the centuries. It is therefore not surprising that gold carries powerful symbolic meanings in western culture.

Because humanity's love of gold has caused so much trouble, and because gold-lust so conveniently

Plate 31, page 46 **Sovereign made from Australian gold at the Sydney Mint in 1855. The first sovereigns and half-sovereigns produced at the new Sydney Mint proudly proclaimed their place of origin. This design inspired the logo for the redeveloped Sydney Mint Museum.**

Powerhouse Museum N 14053

Plate 32, page 47 **Detail of prize medal (see plate 36, page 53).** Powerhouse Museum 90/87

symbolises greed, the relationship has developed a reverse side. This love-hate affair goes back a long way, at least to the fifth century BC. Plato's allegory of the metals in *The Republic* proposes that social order be inculcated by teaching people a myth: that God made the guardians of society from gold, the auxiliaries of silver, and the majority of copper. Yet, immediately afterwards, Plato warns against rulers 'with a fierce secret passion for gold and silver' who will build 'mere private nests where they may squander a lavish expenditure ... '[2]

When Australia teetered on the brink of the gold rushes not everyone was pleased. The Reverend W B Clarke, an amateur geologist, claimed that when he showed a sample of gold to Governor Gipps, His Excellency replied, 'Put it away Mr Clarke or we shall all have our throats cut.' Modern historians believe this was a fabrication invented by Clarke to promote his view that gold and sudden wealth were a potentially corrupting force. The same fear underlay the pious verses on an English Sunderland pink splash-lustre pottery jug about 1860, apparently made as a gift for an emigrating digger and now in the Powerhouse Museum collection. One side depicts the ship *Great Australia*, and the other carries the lines:

The loss of gold is great

The loss of time is more

But losing Christ is such a loss

That no man can restore.

Most people would agree today that gold symbolically represents wealth by virtue of the convention that we agree to use it thus. We nominate it as a convenient and enduring means for representation,

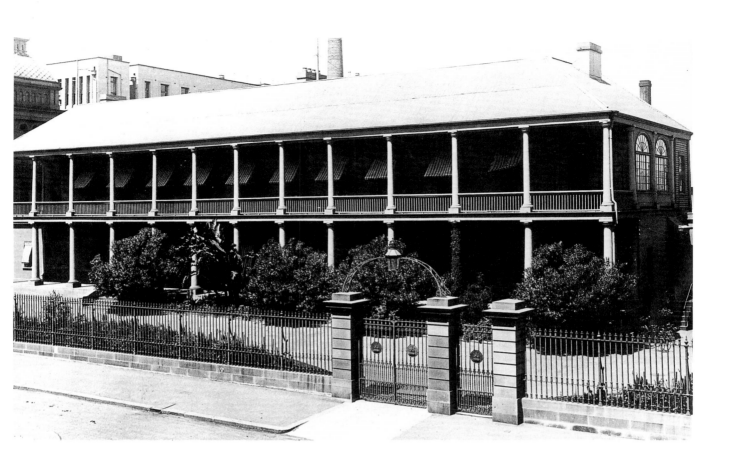

exchange and storage of wealth. The choice of gold for this role may be thought to depend not only on its rarity and its enduring quality as an inert metal, but also on its relative uselessness for other purposes. Until modern technology invented some new uses for it, gold's practical applications were largely limited to dentistry and decoration. However, the modern distinction between gold and wealth has not always applied in the same way.

As soon as word of the Australian gold discoveries got out, people flocked from all over the world. It was not so much the poor, the unemployed and the unattached who rushed to the goldfields — in fact they usually could not afford to travel. At the peak of a gold rush, tradesmen abandoned half-built churches and shoemakers fled their lasts to go to the

Plate 33 **This building, in Macquarie Street, Sydney, was originally the south wing of the 'Rum' Hospital built between 1811 and 1816. It subsequently served as the Deputy Mint Master's residence, government offices, district court and parliamentary library. The building began its life as a museum in 1982.**

Reproduced courtesy of Mitchell Library, State Library of New South Wales.

diggings. Thousands upon thousands of people of apparently settled lifestyle left their jobs and families, or else packed up their families and dragged them halfway around the globe, in often terrible conditions, in the hope of striking it rich. It seems now to be more like mob hysteria than reasoned economic or career decision making.

To understand all this movement, we have to remember that in the last century, with much less social mobility than today, finding gold was one of the few ways — perhaps the only honest and legal way — many people could see to broaden the narrow horizons of their lives or exchange drudgery for luxurious retirement.

In the era when hard currencies were on the gold standard, so that paper money was backed by gold in the State Treasury, gold did not merely symbolise wealth or serve as a convenient means of hoarding and exchange: gold literally *was* wealth. No better illustration can be cited than the economic studies of W S Jevons, the young scientist first employed at the Sydney Mint in the late 1850s. His personal experience in Australia inspired him to study the economic effect of a sudden increase in the gold supply, finding that it was not merely inflationary but actually created a real increase in the wealth of the community. After his return to England, Jevons had a distinguished career, and is regarded as one of the greatest names in the history of economics.

One obvious economic effect of the gold discoveries in Australia was to create a new class of patron, the new rich, with tastes very different from the 'old' moneyed military-pastoral class who comprised the establishment in the convict colonies. As in California and southern New Zealand, the discovery of gold in Australia led to sudden increases in population and also altered the mix of the population and the skills base of society, with important long-term effects. After a temporary skills shortage at the peak of the gold rush there were eventually many artists, architects and artisans for newly rich patrons to employ.

Furthermore, the increase in wealth boosted the development of symbols of national identity in the decorative arts. The patrons, those gold seekers who made money, equated their new homeland with success.

No wonder the jewellery bought by successful diggers for their loved ones celebrated and flaunted not only the gold itself but also the means of winning it and the country where it was found. Not for them the abstract Georgian elegance of the old elite. They wanted a great show of gold in the form of nuggets, picks, shovels and windlasses; or if there were flora and fauna, the more distinctively Australian, the better.

So much for the meanings ascribed to gold; what then was the meaning of a mint? The chief, but not the only role of mints was to process precious metals, turning wealth in the raw into legal tender, thus literally making money. The colloquialism 'to make a mint' still reflects this key role. Wherever legal mints existed, they were regarded as among the elite institutions of the region. Reference to old gazeteers indicates that throughout its decades of operation and even for a few years after it closed, the Sydney Mint (pl. 33), Australia's first, was considered as one of a small group of key public buildings along with the Town Hall and the University.

The site chosen for the Sydney Mint was between Macquarie Street and the Domain, incorporating the former south wing of Governor Macquarie's 1816 'Rum' Hospital which was to be utilised for administration

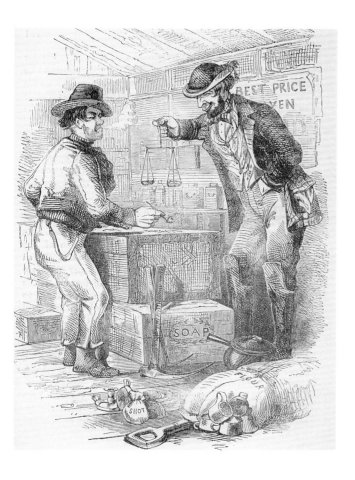

Plate 34 ***The gold buyer,* an illustration
after S T Gill from *Peter Paley's Annual
for 1864* edited by William Martin,
William Kent & Co, London, 1864.**

The existence of the Sydney Mint, and the fact that Sydney was supplying coinage not only for local use but for use around the world, was a matter of great communal pride, expressed in a huge backlit painted transparency hung banner-like on the front of the building on the occasion of the first Royal tour of Australia, in 1867-1868: the painting depicted allegorically 'Australia coining its own currency'.

Similarly, the first sovereigns and half-sovereigns produced at the Sydney Mint carried the words 'Sydney Mint Australia'. The Royal Mint in London did not countenance this departure from the established imagery and this design was soon discontinued but its proud message was clear to all.

Because of the political importance of precious metals in earlier times, scientists and technicians who understood mining, metallurgy and minting had great prestige and earning power and often enjoyed the personal favour of rulers. The rollcall of Masters of the Royal Mint includes the names Isaac Newton and John Herschel. In the 19th century the chemical processes involved and the high technology (for that time) of the mint operations, meant that a mint employed staff of the highest intellectual calibre. Sydney Mint staff made an important contribution to the intellectual life of the city, for example, taking a leading role in the organisation of the Sydney International Exhibition of 1879.

The Sydney Mint produced technically superb medals for various purposes including prize awards and historic commemorations (pl. 35). These were often designed by Australian artists, such as Helena Forde (nee Scott) who in 1872 took a break from the

and commercial trading (and later partly for a residence for the Deputy Master). The Mint was responsible for bringing modern building technologies to Australia in 1854-1855. The melting house, coining factory and associated works which completed the Mint and formed the other three sides of the courtyard were completely different in construction from the old hospital. Behind its stone facade, the coining factory is a pre-fabricated, lightweight structure assembled from components made in England by a team of British Army sappers and miners (later known as the Royal Engineers).

Plate 35 **International Exhibition Award Medal die, 1879. The obverse of the award medal, shown here, depicting a symbolic figure of New South Wales in front of the short-lived Garden Palace, was designed by Samual Begg of Sydney. The design was modified by J S and A B Wyon who engraved the dies which were produced at the parent institution, the Royal Mint in London and were then sent to the Sydney Mint where the gold, silver and some of the bronze medals were struck. D: 5.1cm**

Powerhouse Museum 88/301.1

botanical and entomological illustration which was her livelihood to design the magnificent Yass Medal with its wreath of native flowers (pl. 36).

Until the gold-rush era, relatively little artistic or decorative metalwork was produced in the colonies. There were not many wealthy patrons and fewer competent goldsmiths and jewellers. Furthermore, there was no ready supply of materials so making a new piece often meant melting down an old one. The gold rush and associated mining booms ensured a steady and convenient supply of precious metals.

From the mid 1850s there was a flood of magnificent Australian gold and silverware including epergnes, presentation cups, silver-mounted emu eggs, inkstands and jewellery which often utilised Australian precious and semiprecious stones. Many of these depicted native flora and fauna, and people

Plate 36 **Prize medal of the Yass Pastoral and Agricultural Association, silver, designed by Helena Forde (nee Scott, 1832–1910) in 1872 and struck at the Sydney Mint. The use of Australian metals to convey Australian imagery was not confined to smithing and jewellery but extended also to medallic art. D: 7cm**

Powerhouse Museum 90/87

— both Aborigines and colonists.

So, in conclusion, what did it all mean? It meant that, as so often in history, gold exercised the power traditionally attributed to it, and endorsed by Mr Goldfinger. Everything was changed because gold changed everything. The final nail in the coffin of the convict colonies' social structure was a golden nail. The symbols of the future Australia and developing nationalism were solid gold.

David Dolan was a senior curator of decorative arts and design (1989-1994) and manager, Collection Development and Research (1994-1995).

Notes

1. Ian Fleming, *Goldfinger*, Jonathan Cape, London, 1959.
2. Plato, *The Republic*, Stephanus edition, 548, J M Dent & Sons, London, 1945.

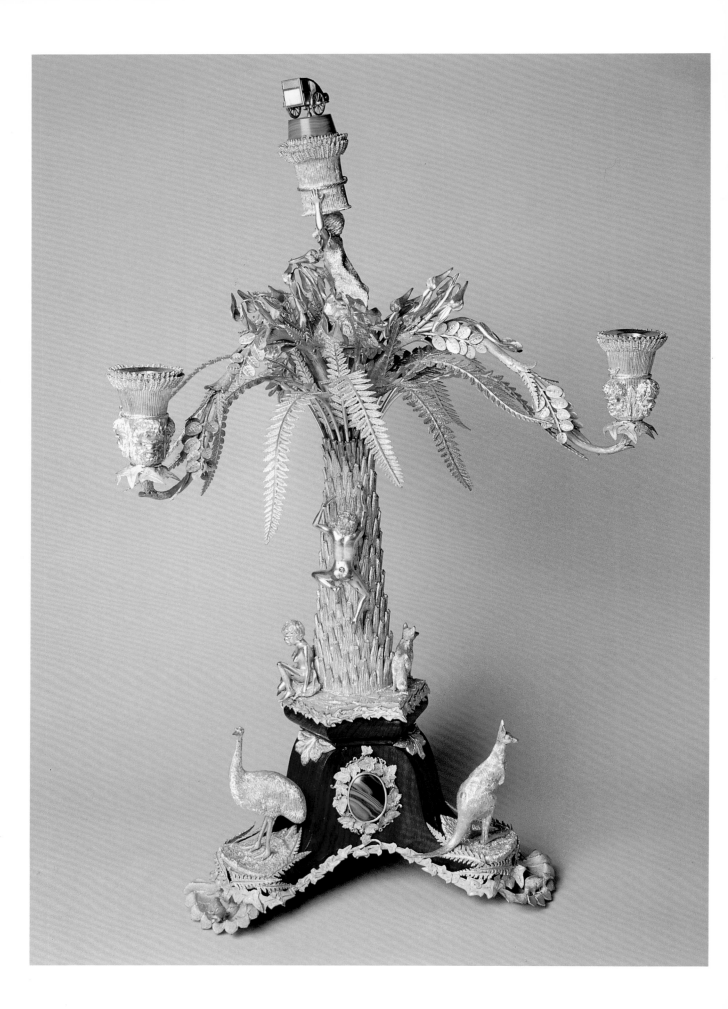

tarnished
silver

PAUL DONNELLY

DEPICTING ABORIGINES IN COLONIAL SILVER

Amongst the silverwork produced during the last half of the 19th century are many pieces which feature distinctly Australian images. Aboriginal figures are frequently used as part of the decoration, often with native animals and plants in a landscape which creates the effect of a miniature diorama. During this period the frontier struggles between the Aboriginal people and European settlers over land spread inland from the south-eastern coastal areas, where the white population was most dense and where these pieces were made.

The Europeans generally believed that the Aboriginal people were a dying race, a view that was held well into this century. It permeated political thought and entered the popular press, literature, the arts and, as illustrated here, the design of decorative silver. This chapter looks at how we might interpret these pieces as representing the perceived taming of the frontier by the settlers and their attitudes towards the Aborigines.

Significant numbers of European silversmiths came to Australia from the mid 1800s and created pieces for patrons who could afford luxury items. The new consumer class bought and commissioned objects produced in silver, often incorporating a token function such as inkstands, jewellery caskets, candelabra or epergnes. Many of these objects were sporting prizes, agricultural trophies or presentation pieces for some notable achievement. An example is the three-branch, frosted silver candelabrum made by Julius Schomburgk around 1860 (pl. 37). It is inscribed: 'Testimonial by the Colonists of South Australia to John Ridley Esq. for the great boon which he has conferred upon the Province by his invention of the reaping machine.'

The Ridley Candelabrum combines many of the elements repeatedly featured on these pieces including most significantly, miniature Aboriginal figures. The candelabrum is designed in the form of a large tree fern (of realistic scale to the figures) which spreads into leaves and three branches with candle holders decorated with reliefs of four Aboriginal faces. The three feet at the wooden base of the tree are occupied by full figures of an emu, kangaroo, and an Aboriginal man holding a shield with inscription and a boomerang. The figures stand on stylised groundcover which together with a duck-billed platypus, possum and a lizard nestling in shells below the feet, create a rudimentary landscape. A female Aboriginal figure and a dingo decorate the base of the tree and a male climbs the trunk. At the pinnacle of the candelabrum the figure of an Aboriginal man kneels amongst life-size Sturt's desert pea flowers and holds a sheaf upon which is displayed a miniature replica of the reaping machine. It is indeed a cruel

Plate 37, page 54 **The Ridley Candelabrum made in silver, gold, malachite and blackwood by Julius Schomburgk, Adelaide, about 1860. H. 67.5 cm. The reaping machine is proudly displayed at the top.** Lent by the University of Adelaide. Photograph courtesy of J B Hawkins Antiques Reference Library.

Plate 38, page 55 **Detail of presentation inkstand attributed to Julius Schomburgk (see plate 43, page 62).** Private collection

irony that a testimonial celebrating a machine designed to maximise agrarian productivity should use images of the people who have been dispossessed of the land.

Although the Ridley Candelabrum and similar pieces use distinctively Australian motifs, their designs owe much to the naturalistic and revivalist styles then so popular in Europe. Many silversmiths in Australia continued to use these styles, the classical revival, particularly, often substituting Aboriginal figures and motifs for classical equivalents such as mythological characters or masks.

One of the most important silversmiths working in this classical style was Christian Qwist. His work includes the 1871 Sydney Cup which is shaped in the form of an ancient Greek urn. On its handles are the reliefs of heads representing the Greek god of wine, Dionysus or Roman Bacchus (pl. 39). Where the face of the Greek deity is depicted on this cup, depictions of Aboriginal heads are similarly incorporated in the Ridley Candelabrum and the plinth of the Duncan Trophy (pl. 40). Attributed to Julius Schomburgk,[1] this centrepiece, made between 1870 and 1875, has three reliefs of Aboriginal heads surrounded by stalks of wheat, vine leaves and grapes.

The transition between European and non-European imagery is smooth; the motif of the head of Dionysus on the Sydney Cup is replaced by the Aboriginal head on this centrepiece. In another example an Aboriginal figure supports an emu egg; a local variant of the Greek demigod Atlas bearing the globe (pl. 41).

The emu egg was an extremely popular element in

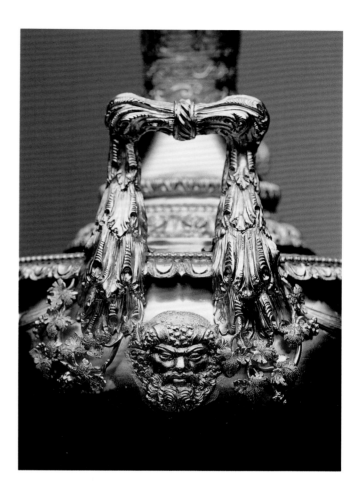

Plate 39 **Detail from under the handle of the 1871 Sydney Cup, by C L Qwist. Classical symbolism is evident in the Dionysus/Bacchus head, grape vine, and egg and dart pattern *(see plate 16, page 26)*.** Powerhouse Museum 94/223/1

Australian silver and provided the silversmith with an exotic souvenir from nature with which to work. The oversize egg acted as proof to the existence of the other exotic people, animals and plants depicted in small-scale silver representations in the design. The use of eggs as decorative elements was not unique as Europeans had worked with ostrich eggs since the 16th century. In the main they tended to be mounted as wonders of nature from unfamiliar and distant

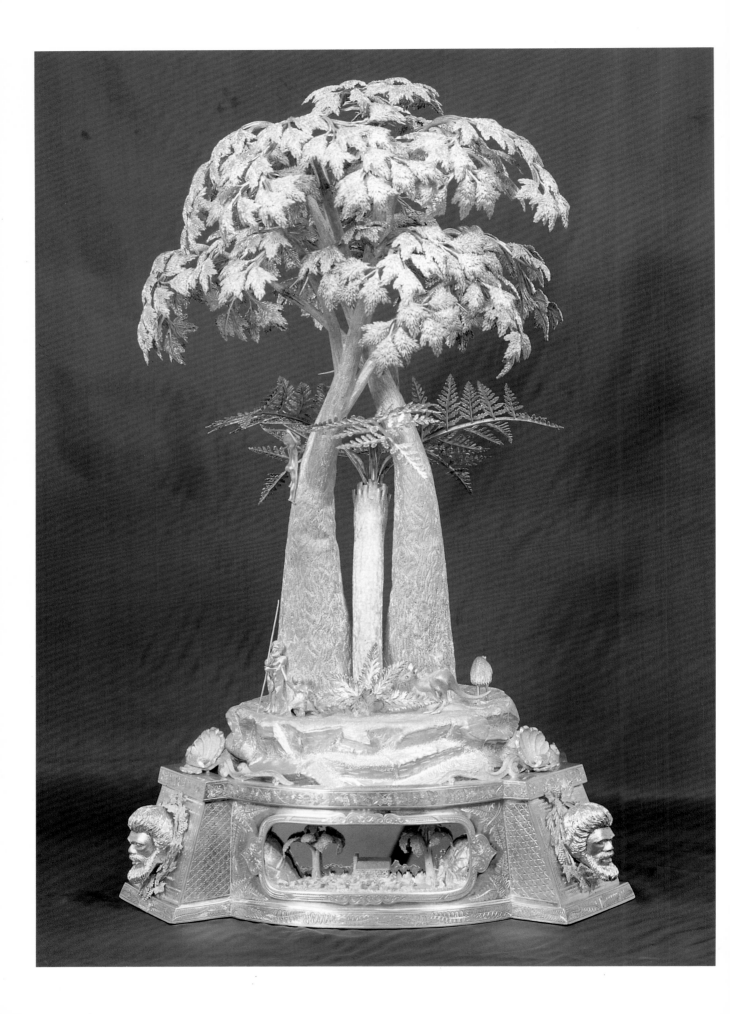

Plate 40, page 58 **The silver Duncan Trophy was made between 1870 and 1875 for the retailer J M Wendt, Adelaide, and is attributed to the silversmith Julius Schomburgk. The design includes the classical motifs of vines and grapes around the heads on the plinth. On the tree an Aboriginal figure pursues a possum but the designer has not allowed for any interaction between the Aborigine and the mounted stockman (obscured behind the trunk).** **H: 66.5cm.** Lent by the Mount Barker Agricultural Bureau.

Photograph courtesy of J B Hawkins Antiques Reference Library.

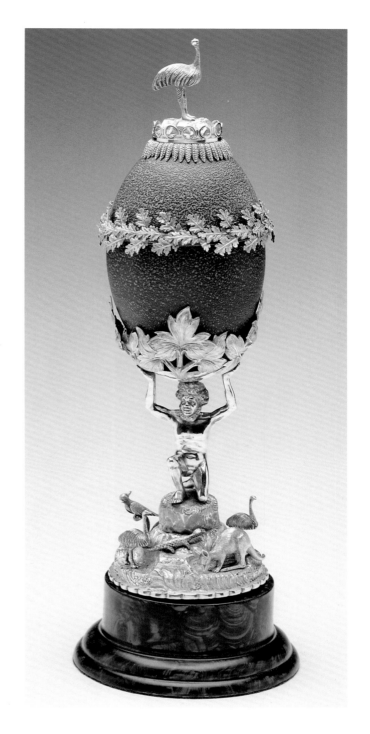

climes and some examples combine the Atlas figure, inspiring the Australian emu egg equivalents. However, the Australian use of an egg within a miniature landscape populated with people, flora and fauna has no parallels amongst ostrich egg pieces. The emu egg was often put to practical use as a container for items such as perfume bottle holders (pl. 42), jewellery or inkwells thereby avoiding the difficult procedure of raising a bowl from the flat.[2]

Many of these objects were assembled from multiple elements selected from precast parts and in a way the egg is another part of that kit. In plate 43 the well-rendered Aboriginal figures are cast from the same mould but one is oxidised black, the other is polished silver. The figures were most likely taken from an available supply rather than deliberately differentiated in colour to appear on the same piece. The awkward kangaroos are technically inferior to the human figures suggesting they came from a different source and therefore were not originally planned to

Plate 41 **In this silver presentation cup the figure supports the emu egg in the same way the classical demigod Atlas was condemned to hold the sky, illustrated in later times as a globe. It was made about 1862 for the retailer H Steiner, Adelaide, and is attributed to J Schomburgk. H: 37.5cm.** Private collection

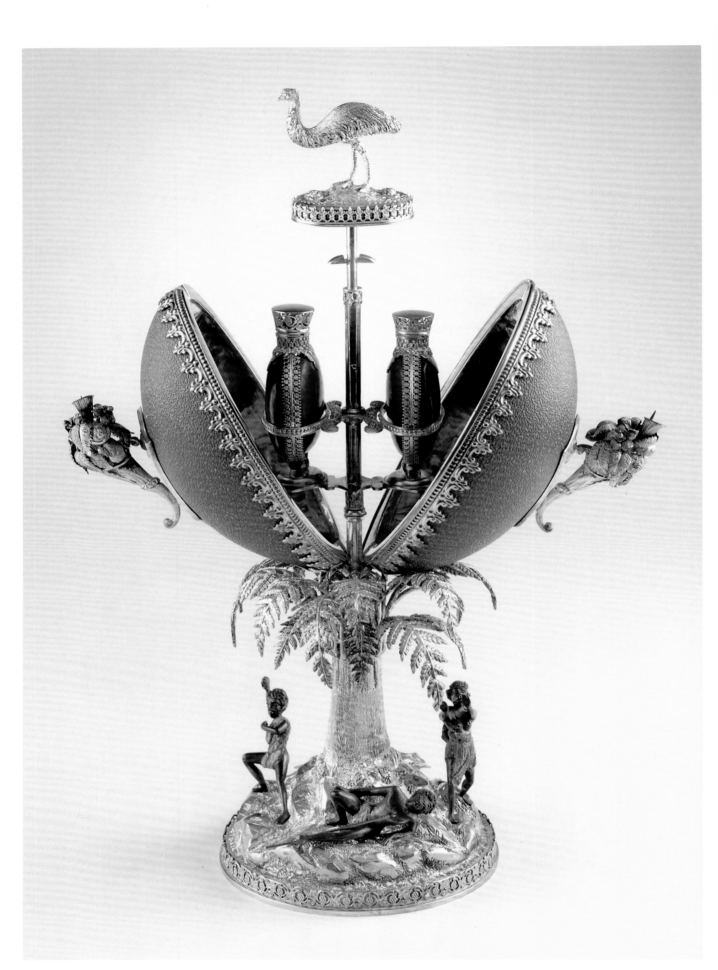

feature on the one piece.[3] Indeed, detached, unused figures survive from workshops.[4] This form of manufacture was based on a given set of components and restricted each design to a predetermined repertoire.

The landscape settings for the Aboriginal figures conform to European preferences for the picturesque rather than any geographical accuracy that may reflect the variety of environments in which Aborigines lived. Rainforest plants such as ferns and tree ferns abound in these scenes (pl. 42) and satisfy the 19th century love of domestic fernery. Within the confines of these miniature environments, the Aboriginal figures are the dominating force. They are shown as masters of the land in a variety of dignified poses (pl. 38) and activities such as hunting (pl. 44). However, their small scale ensured that any control implied was severely minimised. Nor can they be read as providing recognition of the integrity of Aboriginal life. Rather the very creation, purchase and possession of such pieces implied control of the land and subjugation of the Aboriginal people.

By the 1870s when production of these pieces was

Plate 42 **A female Aboriginal figure raises her hands in protest to an aggressor while a man lies wounded on the ground between them. This scene is acted out on a perfume bottle holder by H Steiner, Adelaide, made about 1870 from silver, silver gilt, emu egg and Queensland beans. H: 33.5cm.** Lent by the Art Gallery of South Australia. Gift of the Southern Farmers Group Ltd in its centenary year 1988 through the Art Gallery of South Australia Foundation 1988. 8810A20A

at its height, European opinion and policy towards Aborigines had shifted numerous times since the invasion. A century earlier Captain James Cook as head of a British-funded scientific expedition gave little thought to economic concerns in his comments on 'The Great South Land'. For him the Aborigines were a source of anthropological interest, not an economic threat. His close contact with scientists such as the botanist Joseph Banks undoubtedly exposed him to more enlightened attitudes. His journals convey the belief in the 'noble savage':[5]

> They [the Aborigines] live in a Tranquillity which is not disturb'd by the Inequality of Condition: The Earth and the sea of their own accord furnishes them with all things necessary for life, they covet not Magnificent Houses, Household-stuff etca, they live in a warm and fine Climate and enjoy a very wholesome Air ... this in my opinion argues that they think themselves provided with all the necessarys of Life and that they have no superfluities.[6]

The notion of the noble savage has a long history in European culture but was popularised by the writings published between 1750 and 1780 of the French philosopher and romanticist, Jean-Jacques Rousseau. Through this influence the indigenous people of Australia, North America and the South Pacific were admired for their apparent freedom from vices seen to be inherent in the 'civilised' world. As the Industrial Revolution gathered momentum and western cities became overcrowded, the romantic illusion seemed particularly attractive.

Following the arrival of the First Fleet in 1788 the Aborigines were no longer regarded as romantic

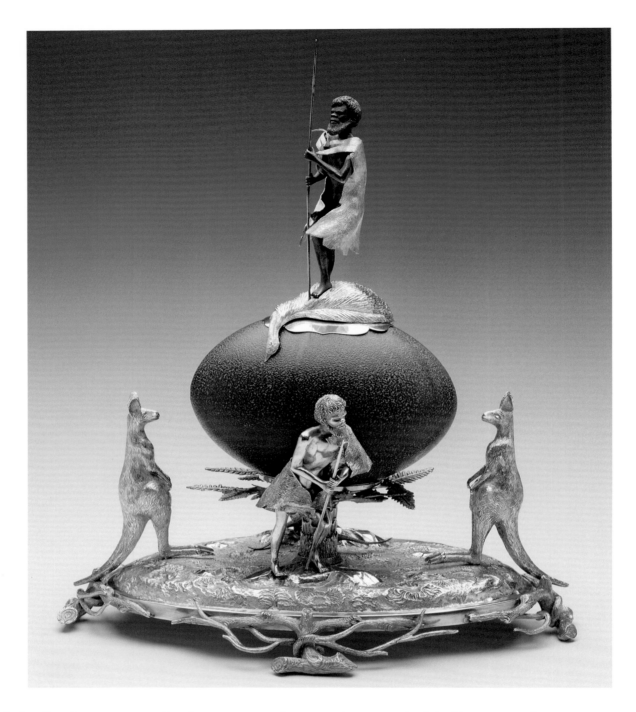

symbols of an innocent past; for the Europeans they became a barrier to occupying the land. The initial and predictable conciliatory approach by the whites was short lived when it became apparent that the Aboriginal population was an obstruction to economic gain. Once white explorers crossed the Blue Mountains in 1813 the colony's full economic potential began to be realised. The resultant gradual movement

Plate 43 **An Aboriginal hunter proudly stands on the vanquished carcass, in the convention of European hunting scenes. This silver and emu egg presentation inkstand, made about 1870, is attributed to Julius Schomburgk; retailed by J M Wendt, Adelaide. H: 31cm.**

Private collection

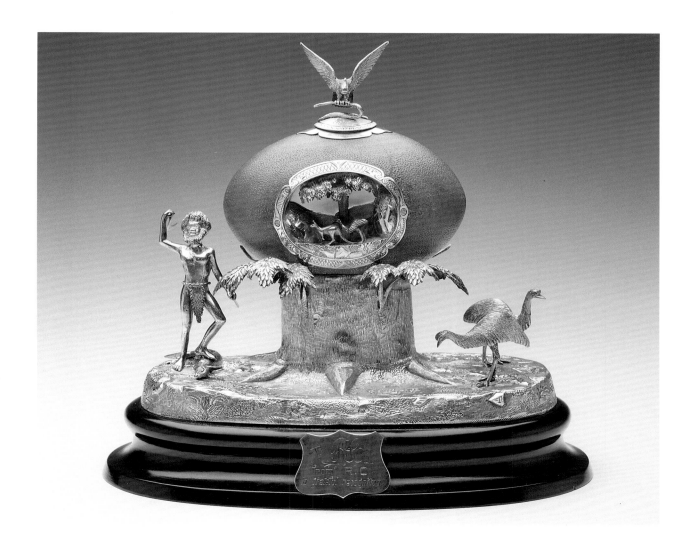

Plate 44 **Silver and emu egg presentation inkstand with hunting scenes, made by J M Wendt about 1875. It is inscribed: 'To R. C. in grateful recognition.' H: 27cm.**

Powerhouse Museum 85/412

inland of squatters and their livestock quickened the pace of militancy amongst the indigenous population. To quote the anthropologist W E H Stanner, 'The great wrecker had been the pastoral industry ... The industry was still expanding in the 1890s and was carrying the chain of like causes and like effects out into the dry zones of the west and centre and into the Northern Territory and Kimberleys.'[7] Warfare raged in many parts of the country with dire consequences for the Aboriginal people who lost lands, culture and language. For the invading settlers advancing on the frontier, terror became part of life.[8] For the Aborigines disadvantaged by fighting with spears against guns, it was potential genocide.

However, in the 1860s and 1870s the frontier and its dangers were distant from the main centres of population.[9] The colonisers increasingly believed that mainland Aborigines were disappearing; a belief that was given credence and momentum by the misapplication of the work of Charles Darwin. His biological theory of evolution, *On the origin of species by means of natural selection*, published in 1859, was

applied to race relations in Australia from the 1860s. The misuse of that theory provided 'the moral justification for dispossession – those best able to exploit the land, or anything else for that matter, have the best right to it'.[10]

Social Darwinism as it became known was embraced wholeheartedly in Australia, becoming a powerful force by the 1870s.[11] This is evident in the patronising literature of the time, for example a member of the Royal Geographical Society of Australasia, S Newland, wrote in 1895: 'My apology is that in discharge of one of its most important functions the Geographical Society has long been anxious to collect all the information that can be obtained respecting a race fast disappearing.'[12]

These were the attitudes that informed the production of the silver pieces. The author John Hawkins describes the silversmiths arriving fresh from Europe, enthusiastically using in their work the novel images of Aborigines, animals and plants.[13] However, their enthusiasm was dependent upon colonial society's relation with, and attitudes to, the Aborigines. With the belief in their inevitable demise it is not surprising that there was an apparent wave of nostalgia for the 'noble savage' amongst a section of the population no longer under threat. Aboriginal Protection Acts were passed in the colonies from the late 1860s. Protection, as interpreted by the government, meant segregation onto missions and reserves away from the main white centres of population. To those artists fresh from Europe, the Aborigines (especially those living a traditional lifestyle) remained a rare sight.

The notion of a race disappearing is a strong element in painting in the decades following the 1870s. The intent was to document the supposedly inevitable extinction of the Aboriginal people, ostensibly as a testimony to this unavoidable state of affairs and to provide a chronicle for the future.

To many artists in the 1880s and 1890s, the perceived fading of the Aborigines provided an irresistible attraction.[14] Portraits of Aboriginal people by artists such as Tom Roberts, Benjamin Minns and Oscar Friström show a decided melancholy. In the portrait, *Aboriginal head – Charlie Turner*, 1892, (pl. 45) Tom Roberts has used a lightly coloured background which gives a halo effect. The eyes are tense and sad, turned upward in a classical expression of the tragic. The portrait is disembodied such that the sitter has no position in society. Writing on this genre of the Aboriginal portrait, Margaret Maynard observed, 'The subjects carry no weapons and are non-aggressive. They are edited representations of truncated and inactive individuals.'[15] By contrast the Europeans painted by Roberts conform to the formal conventions of portraiture in which power is conveyed through pose, elaboration of dress and context. For example in the portrait of the squatter Edward D S Ogilvie, painted in 1895, the subject is in the fastidious dress of a gentleman, shown in three-quarter length wearing a shirt, collar and tie thereby establishing his pre-eminent social position. His eyes are confidently directed forward and command the attention of the viewer. The effect is very different to the truncated and isolated head of Charlie Turner.

Despite the intention to analogise the demise of

Aborigines, portraits such as that of Charlie Turner contain humanity and emotion. He is very much an individual and as a consequence his power had to be attenuated through the methods described. Conversely, the scale of the figures in the silverware, varying in size from 6 to 12 centimetres, means that they cannot be identified as individuals but are generic forms. Within the scenes in which they are portrayed, the figures are disempowered by their miniature stature. They are released into a fantasy scene of activity which unwittingly accorded some recognition of the relationship between Aborigines and their land which is absent from the portraits. Also, due once again to their small scale, an association with weaponry (such as spears, boomerangs and nulla nullas) and the correlation with power which that gives, is very different to the lack of power seen in the portraits. Even when the figures are depicted as wholly subordinate, such as on the photograph holder by Wendt (pl. 46), they are nevertheless placed not on a plain plinth but within the context of the land on simulated groundcover.

A recurring image in these pieces is the celebration of the hunt, a popular sport amongst the gentry, and a common theme in European art. The hunting image provided a 'natural' genre for animals as game, as in the inkstand by J M Wendt, made about 1870. The figure of the Aborigine has his spear raised towards two unsuspecting emus standing on the other side of a tree fern from which sprouts a real emu egg. An alternative hunting style is the figure climbing a tree, club in hand, in pursuit of a possum as seen on the Duncan Trophy. Rarer images are those of Aboriginal

Plate 45 *Aboriginal head — Charlie Turner*, **painted in 1892 by Tom Roberts, Australia (1856–1931). Oil on canvas on paperboard, 39.4 x 29.8 cm.** Reproduced courtesy of the Art Gallery of New South Wales. Purchased 1892.

women. Considering the contemporary lack of knowledge or recognition of women's work, especially that of Aboriginal women, their activities such as fishing and gathering may not have been deemed sufficiently important. Since hunting was a male activity the depictions reflect that division of labour. Female figures occasionally crouch under a shelter or protest during combat, as seen on the perfume bottle holder in plate 42.

Within the hunting theme is a common image as represented on the presentation inkstand illustrated

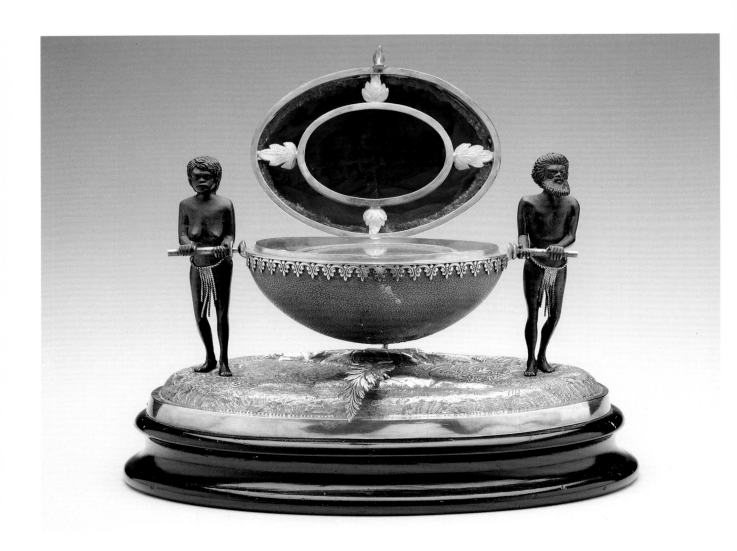

in plate 43. A successful hunter, a spear in his hand, stands proudly with one leg placed on the freshly killed carcass of an emu. This stance is often seen in images of British game hunters where hunting was for sport; the reward a decapitated trophy and a photographic memento of an unequal contest. Such a display of victory in the European convention was designed for the camera; to be effective the pose had to be a frozen image. This was alien to the sense of achievement hunting gave to Aborigines for whom it meant survival.

More disturbing forms of violence in Australian silver involve Aboriginal figures in combat, for example in plate 42, where one figure lies wounded on the ground and a female raises her hands in fear and protest before the attacker. It is hard to imagine the reasons for choosing this subject especially when, as with this object, it is featured on a perfume bottle holder destined for a genteel dressing table. Perhaps they were inspired by earlier and much reproduced neo-classical works such as J L David's painting, *The*

Oath of the Horatii, 1784, or maybe they were inspired by stories or myths of tribal warfare. More insidiously, it is possible they served as a reminder that the Aborigines, to the 19th century European viewer, were after all considered to be savages.

Conversely, on these pieces Aboriginal and European figures are never depicted in combat. Inter-racial encounters are rarely featured, and when they appear there is no interaction. The Duncan Trophy, for example, shows figures in separate worlds yet in the same time frame.

The credence that Social Darwinism gave race relations influenced all aspects of colonial culture and is particularly evident in these elaborate and luxurious pieces of silverware. Against this background we can discern the reasons why Aboriginal representations were used. To reduce a people to decorative elements it was necessary to believe that Aborigines posed no threat or challenge to the European colonisation of Australia. By the 1860s, when these pieces began to appear, there was little for the colonisers in the major centres to fear. This security, combined with the myth of the dying race, established the Aboriginal figure as sufficiently benign to be included as an identifying feature of the Australian landscape; especially at the diminutive scale of the silver objects.

The cultural belief of the 'noble savage' had long since been overturned by the idea of the 'survival of the fittest', and with it came a new attitude towards the Aboriginal people. They were no longer considered a people to admire for their freedom and closeness to nature but were seen as victims of civilisation. A celebration of Australia's uniqueness and the passing of the Aborigines was invoked by silver pieces standing on mantelpieces and dining tables in the burgeoning colonial cities. The strong Aboriginal presence in Australia today shows what mistaken testimonies they were.

Paul Donnelly is a curator of decorative arts and design.

Notes

1. J B Hawkins, *Nineteenth century Australian silver*, vol 2, Antique Collectors Club, Suffolk, 1990, p 54.

2. Hawkins, *Nineteenth century Australian silver*, vol 1, p 26.

3. Hawkins, vol 2, p 58.

4. Hawkins, vol 2, p 92.

5. G Williams, 'Reactions on Cook's Voyage', in I Donaldson and T Donaldson, *Seeing the first Australians*, Allen & Unwin, Sydney, 1985, p 42.

6. B Smith, *European vision and the South Pacific*, 2nd edn, Harper & Row, Sydney, 1985, p 5.

7. W E H Stanner, *After the Dreaming*, The Boyer Lectures, Australian Broadcasting Commission, 1968, p 34.

8. H Reynolds, *Frontier*, Allen & Unwin, Sydney, 1987, pp 9-31.

9. H Reynolds, 'Aboriginal Resistance in Queensland', in *Australian Journal of Politics and History*, vol 2, August 1976, pp 220-222. Far from the main centres it was a different story. As late as 1873 the town of Gilberton in North Queensland was abandoned through fear of Aboriginal attack and in the more remote areas loaded guns were hung in convenient places ready for surprise attack until the early 20th century.

10. B Smith, *The Spectre of Truganini*, Australian Broadcasting Commission, Sydney, 1980, p 15.

11. Smith, *The Spectre of Truganini*, p 15.

12. S Newland, 'Some Aboriginals I have known', in *The Royal Geographical Society of Australasia*, Adelaide, 1895, p 1.

13. Hawkins, vol 1, p 21.

14. M Maynard, 'Projections of Melancholy', in Donaldson and Donaldson, p 94.

15. M Maynard, 'Projections of Melancholy', in Donaldson and Donaldson, p 97.

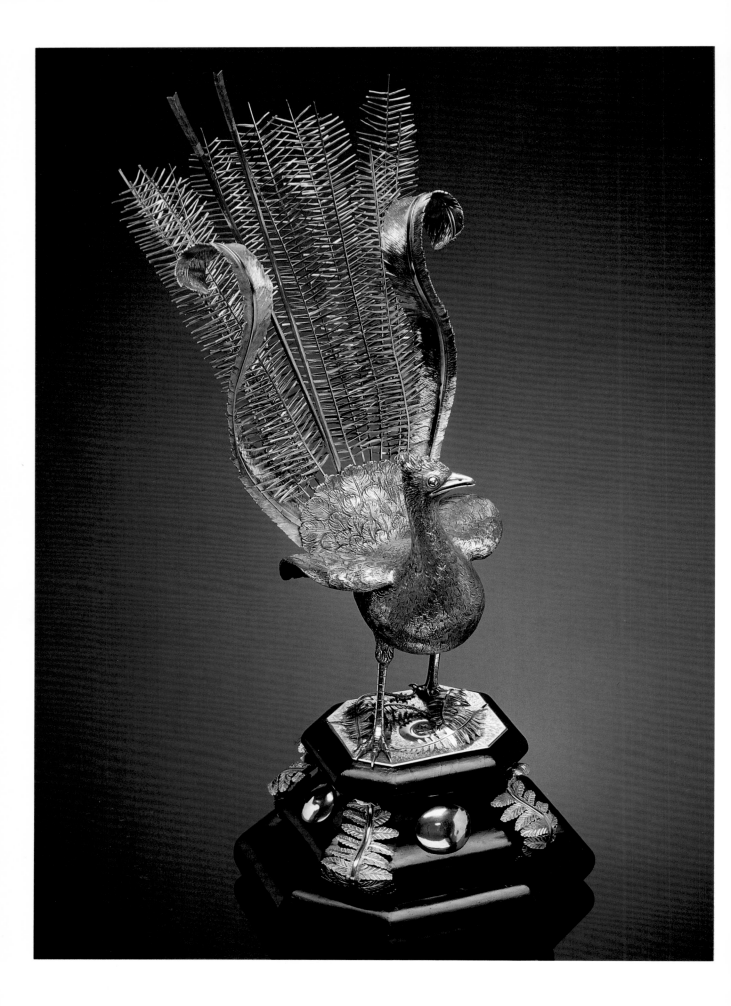

developing a collection

CHRISTINA SUMNER

Museum collections are vital organisms with a lively tendency towards uneven growth. A bequest here, an auction opportunity there and, despite or because of the guiding restraint of collection development policies and the dedication of curators, a collection shifts and settles into a new configuration, its focus altered, a gap filled, a strength augmented, and new possibilities for interpretation created.

The collection of Australian colonial decorative metalwork held by Sydney's Museum of Applied Arts and Sciences consists principally of silver and silver-mounted presentation pieces and gold jewellery produced in the second half of the 19th century. It also includes two fine earlier works and representative holdings of tableware. A number of the latter items bear the marks of early colonial silversmiths, for example, pap boats by Jacob Josephson and Richard Lamb, dated about 1835 and 1840 respectively, and an elegant fiddle-pattern serving spoon of around 1835 by Alexander Dick. Also featured are groups of objects whose significance is anchored in provenance, such as the family silver of John Oxley, Surveyor-General of New South Wales from 1812 to 1828.

The Museum of Applied Arts and Sciences is the parent organisation which administers the Powerhouse Museum, Sydney Observatory and the Sydney Mint Museum. The MAAS is now 115 years old and owes its genesis to the stubborn vision of three men: Alfred Roberts, Australian Museum Trustee, Archibald Liversidge, fellow Trustee and Professor of Geology and Mineralogy at the University of Sydney, and Robert Hunt, Deputy Master of the Sydney Mint. Roberts' preparatory resolution of 1878 declared that: 'a Technological and Industrial Museum with classes for instruction would afford much valuable and practical information to a large class of the community'.[1]

This resolution also recommended that Liversidge should, while in Europe, have a good look at 'the best institutions of similar character'. Two years later, in 1880, Liversidge established the following guidelines for the new museum, thus aligning it with the South Kensington (now Victoria and Albert) Museum: 'It is intended to collect together typical collections of all materials of economic value belonging to the animal, vegetable and mineral kingdoms, from the raw material through the various stages of manufacture, to the final product or finished article ready for use.'[2] Further to this broad brief, he identified fifteen categories of 'specimens', with decorative metalwork subsumed under category number 13: 'Examples of historical furniture and of artistic workmanship in iron and other metals.'[3]

Plate 47, page 68 **Lyrebird presentation piece, made in silver and parcel gilt on an ebonised wooden base, by Henry Steiner in Adelaide about 1880. Unlike many late 19th century presentation pieces which served utilitarian purposes, the lyrebird is purely ornamental. H: 55 cm.**

Powerhouse Museum A10623

Plate 48, page 69 **Detail of presentation inkstand (see plate 54, page 76).** Powerhouse Museum 86/1613

While Liversidge's vision fostered the development of a diverse and international collection, it was the museum's first curator, Joseph Henry Maiden, who insisted that practical research and education were its primary reasons for being. Through observing the raw materials of New South Wales alongside examples of manufacturing, Australians would perceive how to convert their own raw materials into marketable products. Economic independence for the colony would surely follow.

Overall, the collections accumulated during the museum's first eighty years reflect these original aims. Applied arts collecting was largely incidental, accomplished by scientists focused on materials and manufacturing techniques rather than on aesthetics or style. Although the museum was founded during the late Victorian era when ornament proliferated, and elaborate silver epergnes were all the rage on society dining tables, the magnificent and overtly Australian products of colonial silversmiths were not sought after by its early curators. Examination of museum records indicates that with the odd exception it was not until the 1970s that these exquisite works were actively sought.

Maiden's successor in 1898 was Richard Thomas Baker. Both he and Charles Francis Laseron, a collector at the museum from 1906, made links between science and art during the early years of the 20th century. Baker was trained as a botanist and as an artist, and from this dual perspective he enthusiastically promoted the use of Australian flora as a motif in Australian applied arts. Under his direction, objects of aesthetic merit became a collecting field.

Plate 49 **The lid of this snuffbox is embossed with a scene of Sydney Harbour and inscribed: 'Presented by the Colonial Committee to T.B. Daniel Esqr., Commander of the ship *Hercules*, as a token of their sense of the services rendered by him to the Colonists of New South Wales. Jno. Jamison, Chairman. W.C. Wentworth, Dep. Chairman. John Stephen, Hon. Secy. Sydney, 1st October 1835.' The box is crafted from silver with a gilt interior and is attributed to Joseph Forrester, Hobart, with the marks of retailer Alexander Dick, Sydney, made in Sydney in 1835. W: 11.2 cm.** Powerhouse Museum A6611

It was Baker who acquired, in 1907, the museum's first piece of Australian decorative metalwork, a contemporary silver-mounted emu egg by William Kerr. The stock book entry reads, 'Mounted Emu Egg to illustrate the Silversmith's art in the application of the Native Flora for decorative purposes.' As it was acquired under 'Animal samples and products', the bridge between collecting areas is nicely made. Baker also acquired a selection of silver-mounted Australian botanical specimens: photograph frames ornamented

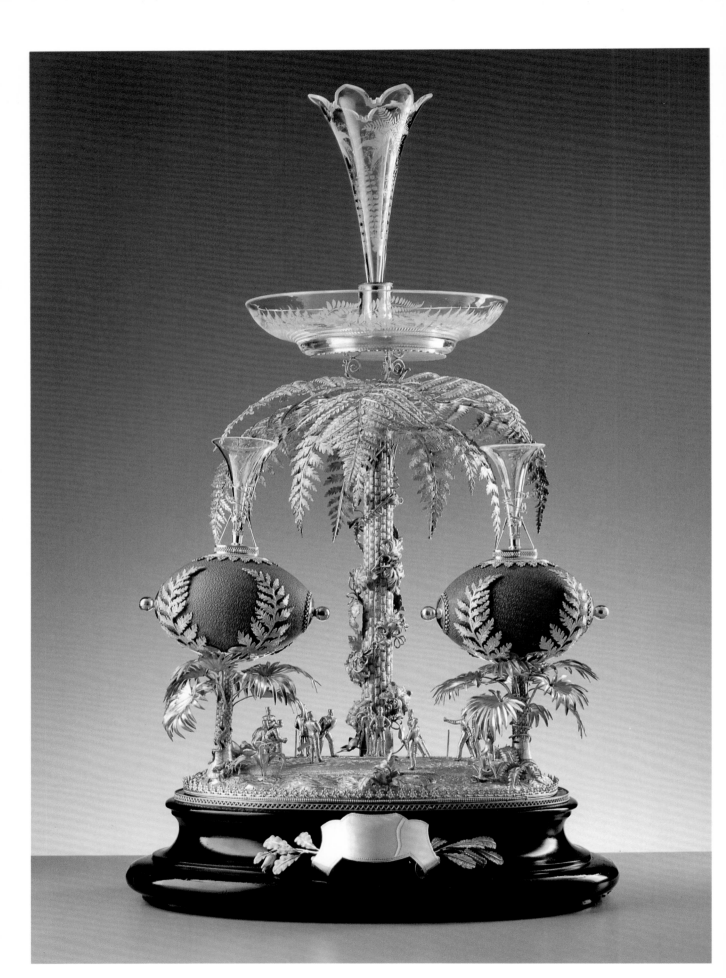

with silver waratahs, a tiny blackbean-pod ewer, two burrawang-nut snuff boxes, and a myrtle-wood match container.

In 1926 Laseron, geologist, palaeontologist and Antarctic explorer, was appointed the museum's first officer-in-charge of applied arts. He helped establish the New South Wales Applied Arts Trust, which set out to assemble a state collection of objects representing the best in design and manufacture. This collection, international in its focus, was eventually handed over to the museum, despite its being viewed essentially as a scientific institution.

Arthur de Ramon Penfold, curator and director from 1927 to 1955, redefined the museum's objectives to reflect technological advances, rather than focusing as previously on applied scientific research. To the familiar formula of natural materials and manufactured products, he added a third: 'To promote craftsmanship and artistic taste by illustrating the history and development of the applied arts of all nations and all times.'[3]

One of the museum's earliest and finest acquisitions of Australian colonial decorative metalwork was a silver cricket trophy, also by William Kerr (pl. 50). The trophy was displayed at the Sydney International Exhibition and given to the museum by Kerr's family in 1938. Coming as it did during the Depression, this gift must have lightened Penfold's heart. A silver skulling trophy dated 1882 and bearing Evan Jones' mark followed in the same year. Mid century, two more significant acquisitions entered the collection by gift: first, in 1954, a magnificent goldfields mining brooch, repatriated to Australia

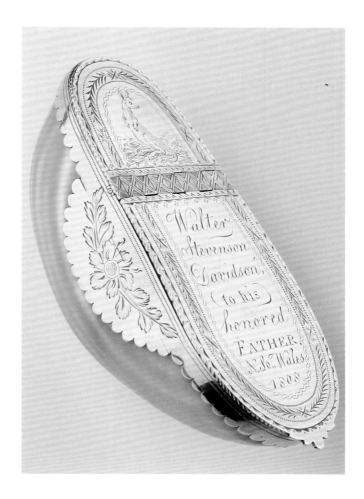

Plate 51 **This small gold-mounted turbo shell snuffbox was probably made by Ferdinand Meurant and bright-cut engraved by John Austin in Sydney about 1808. The box is decorated with a kangaroo after an image by George Stubbs and is inscribed, 'Walter Stevenson Davidson to his honoured father N. So. Wales 1808.' H: 7.1 cm.**

Powerhouse Museum 87/882

Plate 50, page 72 **This cricket trophy made of silver, emu eggs and glass by William Kerr in Sydney about 1878, was awarded first prize at the Sydney International Exhibition of 1879. It was given to the museum by Kerr's family in 1938. H: 72 cm.**

Powerhouse Museum A3221

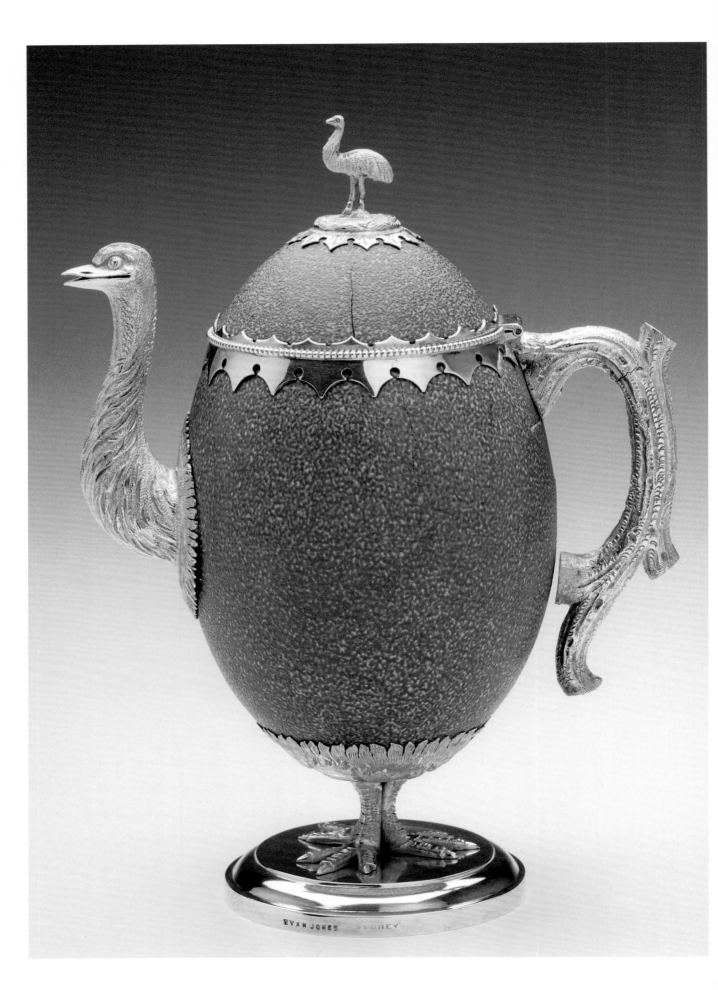

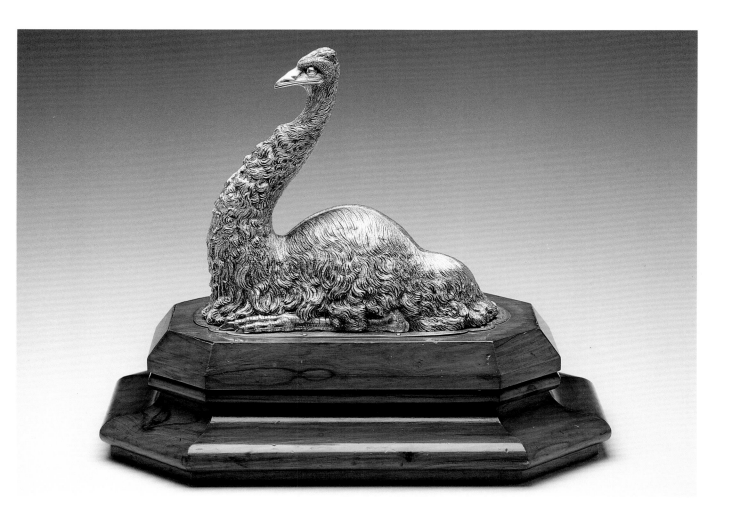

from America by the family of the original owner, (pl. 24) and secondly, in 1960, a silver claret jug of about 1866 by William Edwards of Melbourne.

Chronic shortages of acquisition funds and the costly nature of silver and gold largely account for the limited holdings of Australian colonial decorative metalwork and jewellery in the early collections and for a resulting unevenness in the representation of 19th century Australian material culture. Jack Willis, director from 1960 to 1978, deliberately slowed the acquisition rate in order to accumulate reserves of capital, and then sought to acquire high quality items on the open market. In consequence, significant purchases were made in the field of international, if not Australian, decorative arts.[4] It was not until 1971,

Plate 53 **Presentation inkstand in the form of a nesting emu, made with silver, silver-gilt liner and Bristol blue glass inkwells, on wooden base, by Evan Jones in Sydney about 1875. It is inscribed on the inside, 'Sydney Nov 15th 1902.' H: 35 cm.**

Powerhouse Museum A10359

Plate 52, page 74 **A bachelor teapot made from a silver-mounted emu egg by Evan Jones in Sydney about 1885. The teapot is most likely part of a set exhibited in London in 1886 and in Adelaide in 1887. H: 20.2 cm.**

Powerhouse Museum A6540

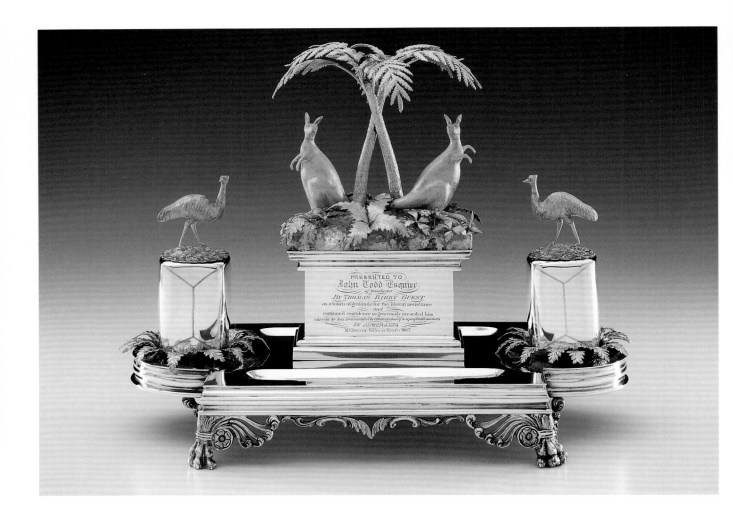

more than forty years after Laseron's resignation in 1929, that a specialist curator of applied arts was appointed as part of a major staff reorganisation. Further specialised staffing followed, and in the 1970s emphasis was at last placed on Australian decorative arts, including metalwork.

The intention was to develop a representative collection of types and styles with emphasis on quality, technique and historical interest rather than rarity or aesthetic appeal. This policy effectively resulted in the choice of key pieces that represented the most common forms of decorative metalwork (sporting trophies, mounted emu eggs, presentation pieces etc) and the major practitioners, but were also definitive – best or early examples, provenance to

Plate 54 This inkstand was commissioned by the Melbourne biscuit manufacturer Thomas Bibby Guest and presented to his English business associate John Todd as thanks for financial assistance given during a crisis in Guest's career. It was made in silver and gold by William Edwards' workshop in Melbourne in 1865 and retailed by Kilpatrick & Company. H: 30.4 cm.

Powerhouse Museum 86/1613

significant people or events. This approach ensured the survival of key types and also maximised the potential for museological interpretation.

Purchases during the mid 1970s were also made with the advice and support of the museum's

Honorary Associates, whose considerable expertise underpinned many recommendations for acquisition. Endorsed by them, for example, in 1976 was a delightful and cleverly designed emu egg teapot by Evan Jones. It was probably part of the tea service shown in London at the 1886 Colonial and Indian Exhibition, and a year later in the New South Wales court of the Adelaide Jubilee Exhibition (pl. 52).

Significant purchases in the late 1970s included gold jewellery (pl. 6), another fine piece by Evan Jones and, in 1977, a superb silver snuffbox bearing the marks of Alexander Dick (pl. 49). The box was presented to Captain Thomas Daniel by the Colonial Committee in 1835, apparently in gratitude for repelling a pirate attack during one of his voyages. On the lid is a rare embossed scene of early 19th century Port Jackson, packed with motifs redolent of colonial life: wool bales, barrels of rum, sail and steam ships, emu, kangaroo, and a reclining Aborigine.

The announcement in 1979 of the Powerhouse Museum development thus came during a period of marked growth in the Australian collections. The appointment of specialist decorative arts curators, together with strong commitment by the museum's Trust, the injection of significant funds for acquisition, and generous sponsorship, ensured planned and steady growth in the applied arts collections overall. In 1983, in considering resources for the thematic approach of the forthcoming Powerhouse development, the museum cited furniture, glass and decorative metalwork as collection areas that needed strengthening in order to render them more useful for display. The gauntlet

Plate 55 **Hinged gold bangle by Henry Steiner, 1878. Steiner may have made it for the Paris International Exhibition of the same year, in Adelaide. Applied to the front of the bangle is scrolled decoration and an inscription. H: 3.5 cm.** Powerhouse Museum 88/677

was immediately picked up, and the weak areas addressed through a number of major purchases.

Among several important acquisitions in the early 1980s, three outstanding 1984 purchases may be singled out. Funds from the Powerhouse Patrons were used to acquire a striking silver presentation inkstand in the form of a large nesting emu (pl. 53). Crafted by Evan Jones, the inkstand was probably made in about 1875 and is inscribed with the date 'November 15, 1902'; it is hinged along one side and opens to reveal a silver gilt lining and two Bristol blue glass inkwells. The second was an exquisitely delicate parcel gilt lyrebird (pl. 47) made by Henry Steiner in Adelaide about 1880. Steiner is one of the most important silversmiths of the period and is known to have

Plate 56 **Brooch of gold and emerald, crafted by an unknown maker in Australia about 1860. Surrounded by waterlily leaves, a kangaroo and emu flank a tall, five-petalled flower with emerald centre. W: 3.5 cm.**

Powerhouse Museum 94/156/3

exhibited at several international exhibitions including the Sydney International Exhibition. In the same year the Jenour Foundation funded the purchase of a silver presentation trowel made in Birmingham by Thomas Marsh & Co, engraved in Evan Jones' workshop in Sydney, and used in 1890 by Henry Parkes to lay the foundation stone of the Paddington Town Hall.

Then in 1986, the museum purchased a fabulous gold and silver presentation inkstand by William Edwards (pl. 54), said to be the only surviving example of his work in gold. Commissioned from Kilpatrick & Company of Melbourne about 1865, the inkstand was a thankyou gift from the Melbourne biscuit manufacturer Thomas Bibby Guest to his old Manchester associate and benefactor John Todd. At the time, it cost him 100 pounds.

A second early colonial snuffbox was added to the collection in 1987 with the acquisition of a small gold-mounted turbo shell example, probably made in Sydney by Ferdinand Meurant and bearing an 1808 inscription (pl. 51). Several varieties of turbo shell are found in the Pacific area. The upper section of the gold mount is ornamented with a bright-cut engraving of a kangaroo styled after George Stubbs' painting of about 1772, while the lower part is hinged and bears the inscription, 'Walter Stevenson Davidson to his honoured father N. So. Wales 1808.'

Australian jewellery purchases in the mid to late 1980s included, in 1988, Australia's bicentennial year and the year the Powerhouse Museum opened, a magnificent and massive gold bangle (pl. 55) by Henry Steiner. The sentimental inscription in French, '*Soyons toujours unis par un divin amour*' (May we always be united by love divine), may indicate that the bangle was made for the Paris International Exhibition of 1878 where Steiner is known to have exhibited.

The museum's collection of colonial decorative metalwork and jewellery is increasingly representative of the principal forms, styles and practitioners of the silversmith's art in 19th century Australia. Notably, the marks of William Kerr, William Edwards, Evan Jones, Henry Steiner and J M Wendt are well represented in the collection. The acquisition of key examples has continued throughout 1994 with the purchase of a group of Australian gold jewellery; this included an openwork brooch of the 1850s with emu and kangaroo flanking a tall emerald-studded flower (pl. 56), and a gold and operculum parure (set of jewellery) by F Allerding & Son (pl. 57). Operculum

comes from the mouth of a sea-snail shell and resembles a 'cats eye' when polished; as a natural phenomenon, operculum appealed greatly to late 19th century taste. Also in 1994, in August, the museum purchased at auction Christian Qwist's outstanding gold Sydney Cup of 1871 (pl. 16).

While all acquisitions to MAAS holdings are regarded as contributions to the formation of a single dynamic collection, and are informed by an all-encompassing collection development policy, the museum's ongoing commitment to the development of Australian colonial decorative metalwork and jewellery within the context of the collection as a whole is now well demonstrated. As the MAAS moves into the mid 1990s, the newly developed Sydney Mint Museum, with its focus on gold and 19th century Australian history, provides added impetus to acquisition in this rewarding area and, in so doing, energetically supports the documentation and preservation in New South Wales of a rich and rare component of Australian material culture.

Christina Sumner is a curator of decorative arts and design.

Plate 57 **This parure or set of matching necklace, locket and earrings was made by Frederick Allerding & Son in Sydney about 1879. It is made of gold and operculum, the shell-valve of the mouth of a sea-snail shell, which is one of many types of shell admired in colonial jewellery. The locket is a later replacement. Necklace diameter: 17 cm.**

Powerhouse Museum 94/156/2

Notes

1. Australian Museum minute book 1874-1879, p 338, in J L Willis, *From palace to Powerhouse: the first one hundred years of the Museum of Applied Arts and Sciences*, unpublished manuscript, Museum of Applied Arts and Sciences, Sydney, 1982.

2. Votes and Proceedings of the Legislative Assembly, Session 1879-1880, vol 3, pp 787-1059, in Willis, p 25.

3. Willis, p 131.

4. Willis, p 218.

exhibition listing

George Richard Addis
1864-1937
● *chain and pendant*
gold, quartz
Kalgoorlie, WA, about 1895
L (chain & pendant): 28.0 cm
Smith family collection, Perth,
Western Australia

F Allerding & Son
1876-1923
● *parure (set) of necklace, locket and
pair of earrings*
gold, operculum
Sydney, about 1879
D (necklace): 17.0 cm
Powerhouse Museum 94/156/2

David Barclay
b about 1804 Scotland
Australia 1830-1884
● *pair of salvers*
D Barclay, retailer
attributed to J Forrester (act.
about 1832-1860s)
silver
Hobart, Sydney (ret.), about
1839
D: 30.0 cm
Inscription: 'Presented by the
Members of the legal profession
in Van Diemen's Land to Alfred
Stephen Esq (formerly Attorney
General of that Colony) upon
his promotion to the Bench of
New South Wales 16 April 1839.'
Private collection

A Blau & Co
Australia act. 1853-1887
● *presentation inkstand*
silver, malachite, emu egg,
textile, glass, wood
Sydney, about 1870
H: 23.0 cm
Inscription: 'Presented to Mr
J. G. Marwick by the Directors
of the Pitt St Congregational
Church & School Penny Savings
Bank as a grateful recognition
of his valuable services as

Honorary Secretary For Eight
Years 17 May 1870.'
Private collection

Robert Broad
Australia act. about 1833-1839
● *snuff box*
R Broad retailer
attributed to J Forrester
silver
Hobart, Sydney (ret.), about
1835
L: 8.9 cm
Inscription: 'To Br. Despard.
Lieut Coll. H.M. 17th Regt.
Presented as a mark of Esteem
from The Masonic Lodges of
New South Wales, Jay. [sic] 6th
1836.'
Private collection

John Brodgen
● *John Mickle Cup*
gold
London, about 1855, refashioned
from the cup made by Bond &
Tofield for Henry Drew,
retailer, in Melbourne, about
1853
H: 26.7 cm
Private collection

August L Brunkhorst
b 1846 Germany
Australia 1875-1919
● *travelling brandy flask and cup*
silver, gilt interior of cup
Adelaide, about 1897
11.0 x 11.7 x 5.7 cm
Inscription: 'W. M. From J.B.S.
1897. [William Mitchel from
Joanna Barr Smith]'
Collection: Art Gallery of South
Australia, Adelaide
Gift of Joanna Simpson in
memory of her mother
Mrs J R Thompson, 1990
● *ball-of-string container*
silver
Adelaide, about 1900
7.1 x 7.0 cm diameter

Collection: Art Gallery of South
Australia, Adelaide
Gift of Joanna Simpson in
memory of her mother
Mrs J R Thompson, 1990
● *sugar basket*
silver, gilt interior
Adelaide, about 1900
14.0 x 13.9 x 8.9 cm
Collection: Art Gallery of South
Australia, Adelaide,
South Australian Government
Grant, 1993

Brush & MacDonnell
Australia 1850-1867
● *breastplate or gorget*
silver
Sydney, about 1851
W: 15.0 cm
Abbrev. inscription: 'Presented
by His Excellency Sir Charles
Augustus FitzRoy Esq Governor
of New South Wales, to Jackey
Jackey, an Aboriginal Native of
that Colony, In testimony of the
fidelity with which he followed
the late Assistant Surveyor
E. B. C. Kennedy, throughout
his exploration of York
Peninsula in the year 1848 ... '
Collection: Mitchell Library,
State Library of New South
Wales, Sydney

Joel John Cohen
Australia act. 1839-1853
● *presentation boxing belt*
engraved by John Caramichael
silver
Sydney, about 1847,
Inscription: 'This belt is
presented by L Folky to Peter
Jackson Champion Boxer of
Australia 2nd October 1886.'
Private collection

Steward Dawson & Co
1885-1947
● *goldfields signet ring*
gold
Perth, about 1898
D: 2.3 cm
Private collection

Hippolyte F Delarue
b France
Australia act. about 1855-1881
● *presentation claret jug*
designed by V A V Delarue
silver
Sydney, about 1875
H: 42.0 cm
Private collection
● *pectoral cross*
gold, silver, rubies, with a
reliquary containing relics of
SS Peter and John
Sydney, about 1870
13.3 x 9.3 cm
Lent by the Trustees of the
Roman Catholic Church for the
Archdiocese of Sydney

Denis Bros
Australia 1860-1910
● *brooch*
gold, quartz
Melbourne, about 1860
4.2 x 5.7 cm
Powerhouse Museum 86/1479
● *brooch and earrings*
gold, agate cameos, rubies,
pearls
Melbourne, about 1875
H (brooch): 8.1 cm
Private collection

Alexander Dick
b 1800 Scotland
Australia 1824-1843
● *snuff box*
A Dick, retailer
unknown maker
silver
Sydney(?), about 1829-1840
9.0 x 6.0 x 2.5 cm
Inscription: 'The passengers of
the Falcon beg Capt John
Adams to accept this small
token in admiration of his
SEAMANSHIP on the passage
to Port Sydney 21st day of May
1829.'
Private collection
● *dog collar*
silver, brass padlock
Sydney, about 1834
D: 12.0 cm

Inscription: 'Mr Mich. Tarrell "Welsh Harp" George Street. Presented to his dog "Tiger" for killing 20 RATS in 2 minutes and 2 seconds. Sydney 1834.'
Private collection

● *snuff box*
A Dick, retailer
attr. to Joseph Forrester (act. about 1832–about 1861)
silver, gilt interior
Hobart, Sydney (ret.), about 1835
3.3 x 7.2 x 11.2 cm
Abbrev. inscription: 'Presented by the Colonial Committee to T. B. Daniel Esqr commander of the ship "Hercules" as a token of their sense of the services rendered by him to the Colonists of New South Wales ... 1st October 1835.'
Powerhouse Museum A6611

Attributed to A Dick

● *chalice, one of pair*
James Robertson retailer
b 1781 Scotland
Australia 1822–1868
silver
Sydney, 1826
H: 18.0 cm
Inscription: 'Presented to the Scots Church, Sydney. By John Dunmore Lang D.D. Minister 1826.'
Lent by Scots Church, Sydney

William Edwards
b London
Australia act. about 1859–1872
● *basket*
silver, ruby glass liner
London, 1856
17.5 x 11.2 cm
Powerhouse Museum 85/1445
● *basket*
silver
Melbourne, about 1859
17.7 x 14.1 x 13.0 cm
Powerhouse Museum A7422
● *presentation cup*
emu egg, silver, gilt interior
Melbourne, about 1859

27.0 x 9.5 x 9.5 cm
Inscription: 'Presented to R A Billing M.A. by the members of the second year Law Class, University of Melbourne 1859.'
Powerhouse Museum 85/450
● *Melbourne Hunt Club Cup*
silver
Melbourne, about 1859
H: 35.0 cm
Inscription: 'Melbourne Hunt Club Cup won by Bobby ridden by his owner James Bevan Esq. October 8, 1859.'
Collection: National Gallery of Australia, Canberra
● *claret jug*
Walsh & Sons, retailer
silver
Melbourne, about 1859–1860
H: 36.0 cm
Private collection
● *presentation cup*
Walsh & Sons, retailer
emu egg, silver, gilt interior
Melbourne, about 1860
Inscription: 'Presented to Capt. Bryant Tonkin by the passengers of Ship "Southhampton" from Plymouth to Melbourne 24 Dec. 1860.'
Private collection
● *presentation cup*
Brush & MacDonnell, retailer
emu egg, silver, gilt interior
Melbourne, about 1860
H: 21.0 cm
Inscription: 'To J.C. From His Son G.C.'
Private collection
● *presentation cup*
emu egg, silver, gilt interior
Melbourne, about 1861
28.0 x 9.0 cm
Inscription: 'Presented by Mr C. Pond to Mrs Stephenson as a souvenir of her son's visit to Australia Melbourne March 1862.'
Powerhouse Museum A6436
● *presentation cup*
emu egg, silver
Melbourne, about 1862
H: 27.0 cm

Private collection
● *presentation cup*
emu egg, silver
Melbourne, about 1862
H: 29.0 cm
Private collection
● *presentation inkstand*
Kilpatrick & Co, retailer
gold, silver
Melbourne, 1865
30.4 x 32.0 x 18.5 cm
Inscription: 'Presented to John Todd Esquire by Thomas Bibby Guest as a token of gratitude for the liberal assistance and continued confidence so generously accorded to him hereby he has been enabled to establish himself in profitable business in Australia. Melbourne Victoria March 1865.'
Powerhouse Museum
Purchased with the assistance of the Silvanus Gladstone Evans bequest, 86/1613
● *chalice and paten, one of a pair*
Walsh Bros, retailer
silver, gilt interior
Melbourne, about 1866
H (chalice): 27.0 cm
D (paten): 15.6 cm
Inscription (under base): 'Presented by the Right Revd. Dr. Shiel, Bishop of Adelaide to The Very Revd Dr. Fitzpatrick V. G. Melbourne Sept. 1866.'
● *claret jug*
silver
Melbourne, about 1866
33.5 x 14.5 cm
Inscription: 'Presented as a token of respect to Br. G. Hewison P. M. by the Adelaide Lodge S. C. 341 August 1866.'
Powerhouse Museum
Gift of H G Hewison, 1960
A5142
● *perfume bottle holder*
emu egg, silver, silver gilt, leather, glass
Melbourne, about 1866–1867
H: 32.0 cm
Collection: National Gallery of Australia, Canberra

Purchased from admission charges, 1982–1983
● *claret jug*
silver
Melbourne, about 1867
H: 44.0 cm
Lent by J B Hawkins Antiques
● *presentation casket*
emu egg, silver
Melbourne, about 1867
Private collection
● *presentation inkstand*
emu egg, silver, gilt, wood
Melbourne, about 1870
H: 25.5 cm
Private collection

Charles Edward Firnhaber
b 1806 Germany
Australia 1847–1880
● *communion plate comprising chalice, paten and flagon*
engraved by Joshua Payne
silver
Adelaide, about 1850, (flagon 1850–1856)
Lent by Christ Church, North Adelaide
● *Hanson Cup*
made in collaboration with J Schomburgk
engraved by J Paine
silver
Adelaide, about 1862
H: 54.0 cm
Lent by Dr Leonard and Phyllis Warnock
● *chalice*
silver, gilt interior
Adelaide, about 1867
H: 26.5 cm
Inscription (on foot): 'Ecclesiae Sancti Agustini Patritius Ryan Walsh Calicem istum donavit 1867.'
Lent by the Salisbury Catholic Parish

Attributed to C E Firnhaber
● *pendant*
gold, cabochon garnet
Adelaide, about 1855
H: 5.3 cm
Inscription: 'A farewell gift from the Ladies of South

Australia 1855.'
Private collection
Displayed with a matching
curb-link bracelet by Steiner.
See *Steiner* listing.

Edward Francis Gunter Fischer
b 1828 Austria
Australia act. about 1857-1891
● *brooch*
gold, shell cameo
Geelong, Victoria, about 1870
H: 3.5 cm
Private collection
● *presentation cup*
emu egg, silver, ebonised wood
Geelong, about 1880
H: 40.0 cm (with base)
Private collection
● *1874 Geelong Cup*
gold
Geelong, Victoria, 1874
H: 25.0 cm
Inscription: 'Won by Mr Tait's
B. H. McCallum Mohr 4 yrs.'
Private collection
● *coursing trophy*
silver
Geelong, Victoria, about 1875
36.0 x 26.5 cm
Collection: National Gallery of
Victoria
Presented through the Art
Foundation of Victoria by John
and Jan Altmann, Founder
Benefactors, 1979-1986
● *claret jug*
silver
Geelong, Victoria, about 1876
H: 43.2 cm
Inscription: 'Elwick 1877'
Private collection
● *Britannia Cup*
Walsh Bros, retailer
silver
Geelong, Victoria, about 1877
H: 48.0 cm
Inscription: 'The Britannia Cup
Presented by the Britannia Fire
Association to The Fire
Brigades of Victoria For
Competition Hose Practice
1878.'
Private collection

● *brooch*
gold
Geelong, Victoria, about 1880
W: 8.0 cm
Private collection
● *John Roberts Cup*
gold, green onyx
Geelong, Victoria, about 1878
H (with base): 37.5 cm
Inscription: 'Presented to Mr
John Roberts, Junr. Billiard
Champion of the World by a
few of his admiring Melbourne
friends as a Memento of his
visit to the Colony of Victoria
20th dec. 1878.'
Private collection
● *cricket trophy*
silver
Geelong, Victoria, about 1887
H (with wooden base): 35.0 cm
Inscription: 'Presented by the
Misses Iddotson to the
Criterion Cricket Club for
Bowling Average won by
J. F. Fischer.'
Private collection
● *1890 Geelong Cup*
gold
Geelong, Victoria, about 1890
H: 34.0 cm
Inscription: 'Won by Messers
Husband & Nicholls, B M
Britannia, 5 yrs, By the
Englishman, DAM Minerva.
Trained by Mr C. J. Nicholls.
Ridden by E. Power, 7st 5 lbs.'
Lent by Rare Art (London) Ltd

Attributed to E F Fischer
● *racing trophy*
W H Stevenson, retailer
silver
Geelong/Adelaide (ret.), about
1890
H: 52.5 cm
Collection: Tamworth City
Gallery

Flavelle Bros & Co
1856-1868
(Flavelle Bros 1850-1921)
● *presentation inkstand*
retailed by Flavelle Bros & Co

attr. to J Hogarth or C L Qwist
gold, silver, malachite, wood
Sydney, about 1862
27.0 x 19.0 cm
Private collection

T Gaunt & Co
about 1852-1979
● *brooch*
gold, amethyst, pearls
Melbourne, about 1870
H: 9.0 cm
Private collection
● *chalice*
design attributed to W Wardell
gold
Melbourne, about 1897
H: 23.5 cm
Lent by St Patrick's Catholic
Cathedral, Melbourne
● *pectoral cross*
design attributed to W Wardell
gold, diamonds, emeralds
Melbourne, about 1897
17.0 x 9.3 cm
Lent by St Patrick's Catholic
Cathedral, Melbourne

Attributed to James Grove
b 1769, England
Australia 1803-1810
pepper caster
silver
Sydney, 1805
H: 14.0 cm
Inscription: 'The first piece of
plate made in V.D Land; A.D.
1805 and used on the
Anniversary of the Birthday of
H.M. George III.'
Private collection

Hackett Bros
1853-1855
● *brooch*
gold, rubies, aquamarine, rose
diamonds
Melbourne, about 1855
9.0 x 5.0 cm
Marked: 'W. Hackett Melbourne'
Private collection

Hardy Bros
Australia 1853-present

● *brooch*
gold, opals, emeralds
Sydney, about 1860
H: 8.0 cm
Private collection
● *bangle*
gold
Sydney, about 1870
H: 2.3 cm
Mary Titchener Collection

Hogarth, Erichsen & Co
1854-1861
● *brooch*
gold, quartz
Sydney, about 1858
5.3 x 6.6 cm
Powerhouse Museum A6486

**Attributed to Hogarth,
Erichsen & Co**
● *brooch*
gold, amethyst
Sydney, about 1858
W: 5.5 cm
Private collection
● *brooch, mourning*
gold, seed pearls, hair, silk,
glass
Sydney, about 1858
W: 5.8 cm
Collection: Queensland Art
Gallery, Brisbane
Gift of Mr and Mrs Alison
Forster, 1990
● *bracelet*
gold
Sydney, about 1860
19.0 x 3.4 cm
Smith family collection, Perth,
Western Australia
● *bracelet*
gold
Sydney, about 1860
H: 5.5 cm
Mary Titchener Collection
● *bracelet*
gold, malachite
Sydney, about 1860
17.5 x 6.9 cm
Private collection
● *brooch*
Brush & MacDonnell, retailer
gold, natural pearl

Sydney, about 1860
H: 7.0 cm
Private collection

Edward Joseph Hollingdale
1832-1882
• *crozier*
gold, myall wood
Sydney, about 1877
H: 180.5 cm
Lent by trustees of the Roman
Catholic Church for the
Archdiocese of Sydney

Evan Jones
b 1846, England
Australia act. 1873-1917
• *presentation inkstand*
silver, gilt, glass, wood
Sydney, about 1875
35.0 x 40.0 x 26.0 cm
Powerhouse Museum
Purchased with the assistance
of Patrons of the Powerhouse,
1984, A10359
• *presentation casket*
emu egg, silver, fabric, gilt,
ebonised wood
Sydney, about 1875
H: 28.0 cm (with base)
Private collection
• *presentation inkstand*
emu egg, silver, ebonised wood
Sydney, about 1875
H: 23.0 cm
Private collection
• *diadem*
silver gilt
Sydney, about 1880
5.7 x 16.8 x 16.5 cm
Powerhouse Museum 94/136/1
• *brooch*
gold
L: 4.5 cm
Sydney, about 1885
Private collection
• *cream jug (matching teapot,
A6540)*
silver, emu egg
Sydney, about 1885
H: 9.0 cm
Collection: Tamworth City
Gallery
• *presentation inkstand*

silver, emu egg, ebonised wood
Sydney, about 1885
24.0 x 20.5 cm
Powerhouse Museum A7227
• *teapot*
silver, gilt interior, emu egg
Sydney, about 1885
20.2 x 15.0 cm
Powerhouse Museum A6540
• *dessert dish*
silver, pearl oyster shell
Sydney, about 1905
17.0 x 26.5 x 22.0 cm
Collection: Art Gallery of South
Australia, Adelaide
Gift of Mr and Mrs G H
Mitchell through the Art
Gallery of South Australia
Foundation, 1980

Timothy T Jones & Son
1853-1926
• *bangle*
gold, white opal
Sydney, about 1880
D: 6.5 cm
Private collection

Ernest Leviny
b 1818 Hungary
Australia act. about 1853-about
1865
• *presentation cups, pair of*
emu eggs, silver, gilt interiors
Castlemaine, Victoria, about
1860
H: 30.0 cm & 28.5 cm
Lent by Buda Historic House
and Garden Inc
• *brooch, probably depicting a scene
of the Public Gardens in Castlemaine*
gold
Castlemaine, Victoria, about
1865
H: 4.6 cm
Private collection

Attributed to E Leviny
• *bracelet*
gold, cabochon garnet, rose
diamonds
Castlemaine, Victoria, about
1855
H: 2.8 cm

Collection: National Gallery of
Victoria, Melbourne
Presented by the estate of Mrs
O V G Scouler, 1967

William Kerr
b about 1839, Ireland
Australia act. 1875-1896
• *cricket trophy*
silver, emu eggs, glass
Sydney, about 1878
72.0 x 40.0 x 31.5 cm
Powerhouse Museum A3221
• *Mayor's Cup*
silver, glass, ebonised wood
Sydney, about 1879
H: 108.0 cm
Inscription: 'Presented by The
Right Worshipful The Mayor of
Sydney C. J. Roberts Esq. to the
A. J. Club 13th Decr. 1879. Won
by Mr. George Fagan's B. M.
Mabel 5 yrs 6st 5lbs, Time 2 m.
398 sec. Distance, one mile & a
half.'
Private collection
• *foundation trowel*
silver, gold, ivory
Sydney, about 1883
L: 34.0 cm
Inscription: 'Presented by
Aldermen of the City of Sydney
to the Mayoress Mrs John
Harris on the occasion of the
laying the foundation stone of
the Great Hall of the Town
Hall Sydney, 13th Novr 1883.'
Lent by Mrs Olwen M H
Atkinson
• *centrepiece*
emu egg, silver ebonised wood
Sydney, about 1884
Inscription: 'Presented to Bro.
Peter William Minshaw
"Forbes" as a token of esteem
by officers and members of
No 13 Empress of India Loyal
Orange Female Benefit Society,
June 1884.'
Private collection
• *Surrey Bicycle Club Trophy*
emu egg, silver, ebonised wood
Sydney, 1885-1889
H: 29.0 x 19.0 x 28.0 cm (with

base)
Inscription: 'The Sydney Cup
presented by the Sydney
Bicycle Club New South Wales
to the Surrey Bicycle Club
England.'
Private collection
• *presentation cradle*
silver, ebonised wood
Sydney, about 1898
H: 13.5 cm (with base)
Inscription: 'Presented to
Alderman J. B. Alderson. Mayor
– Mosman by the Aldermen &
Ex Aldermen With their hearty
felicitations on the Occasion of
the birth of his Twin Children
17th March 1898.'
Private collection

Alfred Lorking
act. 1853-1859
• *brooch*
gold, seed pearls
Sydney, about 1855
H: 4.0 cm
Powerhouse Museum A9878

Joseph Masel & Son
1897-1907
• *brooch*
gold
Fremantle, Western Australia,
about 1898
5.8 x 1.4 cm
Powerhouse Museum A6557

**Attributed to Frederick
Meurant**
(1765-1844) and
John Austin
(about 1760-1837), engraver
• *snuff box*
gold, turbo shell
Sydney, about 1808
7.1 x 3.3 x 2.6 cm
Inscription: 'Walter Stevenson
Davidson to his honoured
Father N. So. Wales 1808.'
Powerhouse Museum 87/882

F Piaggio & Co
1891-1894
• *Coolgardie goldfields brooch*

gold
Perth, about 1895
W: 5.4 cm
Private collection

Priora Bros
1879-1913
● *brooch*
gold, opal
Sydney, about 1900
W: 5.0 cm
Private collection

Christian L Qwist
b about 1818 Denmark
Australia act. about 1853-1877
● *claret jug & goblet*
silver, emu egg
Sydney, about 1865
H (jug): 25.0 cm
Collection: Tamworth City
Gallery
● *standing cup and cover*
Sydney, about 1865
emu egg, silver, gilt
H: 41.0 cm
Collection: National Gallery of
Victoria, Melbourne
Gift of Mr W J Ward, 1963
● *brooch with rose, shamrock and
thistle motifs*
gold
Sydney, about 1870
W: 3.75 cm
Private collection
● *1870 Sydney Cup*
gold
Sydney, about 1870
H: 29.0 cm
Inscription: (front) 'Won by Mr
George Lee's "Barbelle" 4 yrs
carrying 7 st. 10 lb in 3.43 7/10.
(back) 'Sydney' Cup handicap
2 miles Randwick Autumn
meeting 1870.'
Collection: The National Trust
of Australia (New South Wales),
Miss Traill's House, Bathurst
● *Cumberland Cup*
silver
Sydney, about 1871
H: 25.0 cm
Inscription: 'The Cumberland
Cup Weight for Age 1 1/4 mile

won by MR Tait's horse, "The
Count", 2 min. 21 6/10 secs.
Randwick Autumn Meeting,
1871.'
Private collection
● *1871 Sydney Cup*
gold
Sydney, about 1871
H: 25.0 cm
Inscription: 'The Sydney Cup
Handicap Two Miles Won by
Mr Twomey's "Mermaid".'
Powerhouse Museum 94/223/1

Julius Ludwig Schomburgk
b 1819 Germany d 1883 South
Africa
Australia 1850-1891
● *mounted Great Exhibition
medallion*
silver, bronze, blackwood
Adelaide, about 1860
26.8 x 18.0 x 15.5 cm
Collection: Art Gallery of South
Australia, Adelaide
Gift of Robert Davenport 1891
● *Ridley Candelabrum*
silver, gold, malachite,
blackwood
Adelaide, 1860
H: 67.5 cm
Inscription: 'Testimonial by the
colonists of South Australia to
John Ridley Esq, for the great
boon which he has conferred
upon the province by his
invention of the reaping-
machine.'
Collection: University of
Adelaide

Attributed to J Schomburgk
● *bangle*
gold
Adelaide, about 1860
6.1 x 6.8 x 6.1 cm
Collection: Art Gallery of South
Australia, Adelaide
Gift of Miss Jane Peacock, 1945
● *presentation cup*
silver, malachite
Adelaide, about 1860
H: 56.6 cm
Private collection

● *presentation cup*
H Steiner, retailer
emu egg, silver
Adelaide, about 1862
H: 37.5 cm
Private collection
● *Dunedin Centrepiece*
J M Wendt, retailer
silver, glass
Adelaide, about 1864
H: 81.0 cm
Private collection
● *Duncan Trophy*
J M Wendt, retailer
silver
Adelaide, 1870-1875
H: 66.5 cm
Lent by The Mount Barker
Agricultural Bureau
● *Schomburgk Cup*
J M Wendt, retailer
silver
Adelaide, 1865
H: 46.0 cm
Inscription: 'Presented to
R Schomburgk, Esq, Ph D, as a
token of respect and esteem by
his friends in Gawler and its
neighborhood Gawler Dec.
1865.'
Lent by the Adelaide Botanic
Gardens and State Herbarium
● *presentation inkstand*
J M Wendt, collaborator and
retailer
emu egg, silver
Adelaide, about 1870
H: 31.0 cm
Private collection

J Henry Steiner
b 1835 d 1914 Germany
Australia 1858-1884; 1887-1889
● *bracelet*
(displayed with matching
pendant attributed to
Firnhaber)
gold
Adelaide, about 1860
D: 7.5 cm
Private collection
● *Strathalbyn Rifle Association
Ladies' Prize Cup*
silver, gilt

Adelaide about 1862
39.5 x 14.4 x 14.5 cm
Inscription: 'Strathalbyn S. E.
Rifle Association Ladies Prize
won by Willm. Colman Esq: of
the Free Rifles. Distances 500.
700 & 900 Yad 7 rounds each
distance 22 points April 3rd
1862.'
Collection: Art Gallery of South
Australia, Adelaide
Gift of D Keith and Diana L
Goldsmith, 1984
● *perfume bottle holder*
silver, gilt, emu egg,
Queensland beans
Adelaide, about 1870
33.5 x 24.0 x 11.8 cm
Collection: Art Gallery of South
Australia, Adelaide
Gift of Southern Farmers Group
Ltd in its centenary year 1988
through the Art Gallery of
South Australia Foundation,
1988
● *presentation inkstand*
emu egg, silver, wallaby feet,
ebonised wood,
Adelaide, about 1870
H: 28.0 cm (with base: 5.0 cm)
Private collection
● *P F Bonnin Cup*
silver, gilt interior
Adelaide, about 1872
42.5 x 16.0 cm diameter
Inscription: 'P.F. Bonnin Esqr.
Hon: Secretary Adelaide Club.
From The Members. Octr. 1872'
Collection: Art Gallery of South
Australia, Adelaide
South Australian Government
Grant, 1993
● *brooch*
gold, shell cameo (marked:
Mazzoni)
Adelaide, about 1875
H: 6.0 cm
Private collection
● *perfume bottle holder*
silver, emu egg. wood
Adelaide, about 1875
Private collection
● *claret jug*
emu egg, silver

Adelaide, about 1878
H: 30.0 cm
Private collection
• *bangle*
gold
Adelaide, about 1880
3.2 x 5.9 x 6.8 cm
Inscription: *'Soyons toujours unis par un divin amour.'*
Powerhouse Museum, 88/677
• *bangle*
gold, jet, diamonds, natural pearls
Adelaide, about 1880
D: 6.4 cm
Collection: National Gallery of Australia, Canberra
Joseph Brown Fund, 1981
• *claret jug*
emu egg, silver
Adelaide, about 1880
29.1 x 10.5 cm
Collection: National Gallery of Victoria, Melbourne
Presented through the Art Foundation of Victoria by John and Jan Altmann, Founder Benefactors, 1979-1986
• *Lyrebird presentation piece*
silver, gilt, ebonised wood
Adelaide, about 1880
55.0 x 20.0 x 34.0 cm
Powerhouse Museum A10623
• *necklace*
gold, moss agate
Adelaide, about 1880
D: 16.0 cm
Private collection
• *presentation claret jug*
silver
Adelaide, about 1880
H: 46.3 cm
Collection: National Gallery of Victoria
Presented through the Art Foundation of Victoria by John and Jan Altmann, Founder Benefactors, 1979-1986
• *Adelaide Hunt Club Cup*
gold
Adelaide, about 1881
H: 37.0 cm
Inscription: 'Adelaide Hunt Cup 1881. Presented by R.Barr Smith.

Won by Robertson Bros., b.g. Roebuck. Ridden by T.G. Barker.'
Lent by Rare Art (London) Ltd
• *George Hamilton testimonial casket*
silver, gilt interior
Adelaide, about 1881
31.0 x 54.0 x 31.0 cm
Inscription: 'Presented to George Hamilton, Esq J.P. Commissioner of Police, by the Officers Non Commissioned Officers and Constables of the South Australian Police Force. June 1881.'
Collection: Art Gallery of South Australia, Adelaide
Gift of Miss Wyatt, 1884
• *Adelaide Hunt Club Cup, 1883*
silver
Adelaide about 1883
44.8 x 19.0 x 11.8 cm
Inscription: 'Adelaide Hunt Club Cup 1883. Won by "Kildare" The property of Mr James Hay. Master A.H.C. Ridden by Mr T. MacFaie. Distance 4 Miles. Time 9m. 36 sc.'
Collection: Art Gallery of South Australia, Adelaide
Gift of Southern Farmers Group Ltd in its centenary year 1988 through the Art Gallery of South Australia Foundation, 1988
• *tankard*
ostrich egg, silver, silver gilt
Adelaide, about 1883
18.0 x 17.0 cm
Collection: National Gallery of Australia, Canberra
Purchased from admission charges, 1982-1983

W J Turner
act. 1862-1867
• *brooch*
gold, yellow citrine
Beechworth, Victoria, about 1880
H: 4.8 cm
Private collection

Walsh Bros
about 1860-1881
• *brooch*
gold, pearls, enamel
Melbourne, about 1875
7.0 x 4.8 cm
Private collection
• *set of foundation tools for the Wilson Hall, University of Melbourne*
silver, blackwood
Melbourne, about 1879
Private collection

Attributed to Walsh & Sons
• *brooch*
gold, emeralds, diamonds, enamel
Melbourne, about 1870
W: 5.5 cm
Private collection

J M Wendt
1854-present
• *presentation cup*
emu egg, silver, paint
Adelaide, about 1875
H: 33.0 cm
Private collection
• *presentation inkstand*
emu egg, silver
Adelaide, about 1875
27.0 x 27.0 x 16.0 cm
Powerhouse Museum 85/412
• *presentation inkstand*
emu egg, silver
Adelaide, about 1875
H: 27.0 cm (with base)
Private collection
• *Full-Bodied Red Wine Prize Cup*
silver, silver gilt interior
Adelaide, about 1876
35.5 x 12.5 x 19.0 cm
Inscription: 'Awarded To Joseph Gilliard For Full bodied Red Wine February 1876. S. Davenport President C.J. Coates Secretary.'
Collection: Art Gallery of South Australia, Adelaide
Bequest of Joseph Gilliard, 1927
• *parure (set) of hinged bangle, brooch, pair of earrings*
gold, diamonds

Adelaide, 1889
W (bangle): 6.4 cm
H (brooch): 7.7 cm
Inscription: 'Presented to the Lady Mayoress (Mrs Shaw) By Citizens Of Adelaide September 1889.'
Private collection
• *brooch*
gold, gold-bearing quartz
Adelaide, about 1890
W: 6.2 cm
Private collection
• *photograph holder*
emu egg, silver, glass, fabric, ebonised wood
Adelaide, about 1890
H: 19.0 cm (closed); 25.0 cm (open)
Private collection
• *Block 10 Mine*
silver
Adelaide, 1893
37.5 x 30.0 x 30.0 cm
Inscription: 'Presented by the Shareholders of the Broken Hill Proprietary Block 10 Company Limited in terms of their unanimous resolution of November 24th, 1892 to John Warren, Esquire in recognition of his fidelity as General manager of the Company during the arduous and anxious period of the memorable strike among the Barrier Miners, July-November 1892.'
Lent by the Broken Hill Historical Society Inc
• *Lorna Gillam Todd tea and coffee service (6 pieces)*
silver
Adelaide, about 1900
H: 30.0 cm (coffee pot)
Private collection

Attributed to J M Wendt
• *brooch and earrings*
gold, malachite
Adelaide, about 1860
H (brooch): 6.0 cm
Powerhouse Museum A9879

Frederick William Woodhouse, senior

1820-1909

● *designs for presentation trophies (5)*
paper, ink, pencil, watercolour
Melbourne, 1870s-1890
Private collection

● *Mermaid, jockey, owner and trainer*
oil on canvas
Melbourne, about 1871
49.0 x 71.5 cm
Powerhouse Museum 94/223/2

Objects by unidentified makers

● *brooch*
gold, garnets
Melbourne or Ballarat, about 1855
W: 8.0 cm
Reverse inscribed: 'Presented Melbourne Dec 28 1855 to Madame Lola Montez by her Friends in Victoria as proof of their esteem.'
Private collection

● *goldfields brooch*
gold
about 1855
W: 5.5 cm
Private collection

● *goldfields brooch*
gold
about 1855
W: 6.5 cm
Lent by Misses G & G Lewis

● *goldfields brooch*
gold
about 1855
8.5 x 6.0 cm
Powerhouse Museum A9876

● *goldfields brooch*
commissioned by Edward Austin
gold
Sydney (?), about 1855
4.5 x 4.6 cm
Powerhouse Museum A4478

● *Ballarat goldfields brooch*
gold
Ballarat, Victoria, about 1860
W: 5.7 cm
Private collection

● *brooch*
gold, diamond, rubies
about 1860
H: 3.0 cm
Mary Titchener Collection

● *brooch*
gold, emerald
about 1860
W: 3.5 cm
Powerhouse Museum 94/156/3

● *brooch with an Aboriginal figure motif*
gold
about 1860
W: 5.0 cm
Private collection

● *brooch with photograph of Harry Stephan*
gold, glass
Sydney, about 1860
H: 5.0 cm
Inscription on heart: 'Forget me not'
Private collection

● *brooch with an ambrotype of man holding a nugget*
gold
about 1860
H: 6.3 cm
Private collection

● *goldfields signet ring*
gold
1.4 x 2.0 cm diameter
about 1860
Inscription: 'Industry'
Private collection

● *brooch*
gold, pearls, emerald
Ballarat (?), about 1864
5.0 x 5.0 cm
Inscription at the back: '*Erinnerung an Ballarat, 14 December 64*'
Private collection

● *brooch*
gold
about 1870
W: 4.5 cm
Private collection

● *brooch*
gold
about 1870
W: 5.0 cm
Private collection

● *brooch and earrings*
gold, natural pearls
about 1870
H (brooch): 4.6 cm
Inscription: 'Australian gold'
Powerhouse Museum 87/271

● *brooch with a photograph of a young man taken by a Melbourne photographer*
gold, about 1870
H: 6.0 cm
Powerhouse Museum 94/156/1

● *brooch with reversible photograph locket*
gold, glass
about 1870
H: 5.5 cm
Lent by Mrs H R Jenkins

● *earrings*
quandong seeds, gold
about 1870
H: 4.0 cm
Private collection

● *fob pendant*
gold, malachite
about 1870
D: 3.8 cm
Private collection

● *locket with a photograph of a man*
gold, glass
about 1870
H: 4.6 cm
Mary Titchener Collection

● *brooch and earrings*
gold
about 1875
D (brooch): 4.2 cm
Private collection

● *brooch and earrings*
gold, emeralds, pearls
about 1875
H (brooch): 5.0 cm
Mary Titchener Collection

● *brooch, reversible*
gold, shell cameo
Adelaide, about 1875
H: 7.0 cm
Smith family collection, Perth, Western Australia

● *brooch*
cowrie shell, gold
about 1880
4.5 x 3.7 cm
Private collection

● *brooch (octagonal)*
gold
about 1880
H: 4.8 cm
Mary Titchener Collection

● *brooch in the form of a fish*
gold, gold bearing quartz
about 1895
W: 6.9 cm
Private collection

● *Kalgoorlie goldfields brooch*
gold
Western Australia, about 1895
W: 5.5 cm
Private collection

● *Leonora goldfields brooch*
gold
Western Australia, about 1895
W: 5.6 cm
Private collection

● *Poseidon brooch*
gold
Western Australia, about 1895
W: 4.3 cm
Private collection

● *signet ring with swan motif*
gold
Western Australia, about 1895
W: 5.2 cm
Private collection

● *brooch 'Jubilee 1897'*
gold, rubies
Western Australia, 1897
W: 5.0 cm
Smith family collection, Perth, Western Australia

● *Bullfinch brooch*
gold
Western Australia, about 1910
W: 5.8 cm
Private collection

index

Figures in *italics* refer to page numbers of illustrations.